20TH CENTURY MASTERS: THE THYSSEN-BORNEMISZA COLLECTION

20TH CENT

MADE POSSIBLE BY A GRANT FROM UNITED TECHNOLOGIES CORPORATION

National Gallery of Art, Washington, D.C.

Wadsworth Atheneum, Hartford, Connecticut

The Toledo Museum of Art, Toledo, Ohio

Seattle Art Museum, Seattle, Washington

San Francisco Museum of Modern Art, San Francisco, California

The Metropolitan Museum of Art, New York, New York

URY MASTERS=

The exhibition was organized and circulated by the
International Exhibitions Foundation
Washington, D.C.
1982–1983

This exhibition has been made possible by a grant from United Technologies
Corporation and an indemnity from the Federal Council on the Arts and the
Humanities. The catalogue is underwritten by United Technologies Corporation.
Additional assistance has been provided by the Government of the Canton of
Ticino, the Ticino Tourist Authority and the Lugano Tourist Office.

Library of Congress Catalogue Card No. 81-83993
ISBN: 0-88397-039-2

Catalogue designed and produced by Birdsall & Co.
Designer: Derek Birdsall
Color reproduction supervised by Eric Roberts
Typeset in 11/12pt Monophoto 20th Century
and printed in England by Balding + Mansell

First printing April, 1982

THE THYSSEN-

Acknowledgments

It is with the greatest pleasure that the International Exhibitions Foundation presents this second tour of paintings from the incomparable collection of Baron H. H. Thyssen-Bornemisza.

A worthy successor to the recent tour of Old Master paintings from the Baron's collection, the present exhibition features sixty-six outstanding examples from his equally impressive collection of twentieth-century masters. Many of the foremost artists of this century are represented, including the masters of Expressionism and Cubism, Russian Constructivism, Futurism, Surrealism and the New York School. But unlike the Old Master paintings, which are housed in a formal picture gallery constructed especially for their display and are accessible to the public, these modern canvases are the paintings with which the Baron lives. These are the paintings to which the Baron turns for a moment of reflection or contemplation, and he speaks of them as one would speak of close personal friends. It is therefore testimony to their great generosity that the Baron and Baroness Thyssen-Bornemisza are willing to part with these works for a lengthy period in order to share them with American audiences. We extend to them our warmest thanks.

We are fortunate to have as guest director for this project our longtime friend and trustee William Lieberman, who has brought to the selection and catalogue his exemplary scholarship and extraordinary vision. Despite pressing duties as Chairman of Twentieth Century Art at The Metropolitan Museum of Art, he has nonetheless devoted countless hours to revising and refining the selection and to writing his excellent catalogue text. It has been a privilege and a pleasure to work with him.

Our thanks go also to His Excellency Dr. Anton Hegner, the Ambassador of Switzerland, for kindly agreeing to serve as honorary patron of the exhibition during its tour. We are greatly indebted to Pierre-Yves Simonin and Bruno Weber of the Swiss Embassy for their support throughout the organization of the exhibition and tour.

It is always a pleasure to acknowledge those organizations that have provided financial assistance for a major project. United Technologies Corporation, the exhibition's sponsor, has not only given a most generous grant in support of the exhibition but has also underwritten the cost of producing the catalogue. Gordon Bowman, Director of Corporate Creative Programs for United Technologies, has been especially helpful and cooperative throughout this endeavor and deserves our deepest gratitude.

Additional support for the exhibition and tour has been received in the form of an indemnity from the Federal Council on the Arts and the Humanities. Such assistance is becoming increasingly important as the costs of exhibitions rise. We are most grateful to the Council for the invaluable service they continue to render to the museum community.

A project of this complexity could not have been accomplished without the efforts of many friends and colleagues. At the Thyssen Collection in Lugano we owe a special debt of thanks to Curator Simon de Pury, who has given tirelessly of his time and expertise at every stage. Thanks also go to Mrs. Carola Jokisch and Mrs. Gertrude Borghero at the Collection for all they have done to ensure the success of the exhibition. The directors and staffs of the six participating museums have been cooperative in every way.

The exhibition catalogue, beautifully printed by Balding + Mansell, was produced with the capable assistance of Guy Dawson of that firm and Janet Walker of the Foundation staff. Derek Birdsall's thoughtful and imaginative design has resulted in a particularly handsome publication, and we have enjoyed this opportunity to work with him.

Lastly, I want to express my gratitude to the entire staff of the Foundation, and in particular Christina Flocken, Taffy Swandby and Bridgett Baumgartner, who, with their customary efficiency, saw to the innumerable practical details of the exhibition and tour.

Annemarie H. Pope
President
International Exhibitions Foundation

BORNEMISZA

We are delighted to be associated once again with Baron Thyssen-Bornemisza and his marvelous collection of paintings.

The two-year American tour of the Baron's Old Master paintings, just concluded, was visited by more than a million people and was immensely popular in every city on the itinerary.

We believe this show will be equally well received, and we are especially pleased that in this case United Technologies supports not only the tour but also this handsome catalogue.

We hope both bring much pleasure to the nation's art enthusiasts.

Harry J. Gray
Chairman and Chief Executive Officer
United Technologies Corporation

COLLECTION

It is perhaps unnecessary to remind the reader that today the greatest private collection of Old Master paintings belongs to Baron H. H. Thyssen-Bornemisza. With one or two exceptions these pictures are displayed in the galleries attached to his family's Swiss residence, "Villa Favorita," that dominates a meticulously forested mountain overlooking the Lake of Lugano near the Italian border. One-half of the paintings were chosen by his father who had moved to Switzerland in 1933, and at the core of the collection that the first Baron formed are superb examples by German masters. After his father's death in 1947, Baron Thyssen-Bornemisza added masterworks by Italian, Dutch, Spanish and French masters. Today, the collection consists of more than 550 paintings.

In 1979, with extraordinary generosity, the Baron allowed a selection of some fifty of his Old Master panels and canvases to be seen across the United States during a period of two years. The exhibition opened at the National Gallery of Art in Washington, and concluded its tour at The Metropolitan Museum of Art in New York. Assembled by the International Exhibitions Foundation and sponsored by grants from United Technologies Corporation and from the National Endowment for the Arts, the exhibition was seen by more than one million visitors. Such an opportunity can never again be repeated.

In 1960 Baron Thyssen-Bornemisza began to look closely at the art of his own century, and he decided to form an additional collection, this time completely chosen by himself. He regarded the project as an adventure, and he did not realize what a passionate obsession it would become. Today his modern collection is still in transition. It makes, as yet, no attempt to illustrate every aspect of 20th century art. Nevertheless it contains masterworks of our time, and the Baron's acquisitions continue at such a rapid pace that any exact definition of his 20th century collection must wait. The present selection does not extend beyond the Baron's acquisition of Gino Severini's pyrotechnic *Expansion of Light* purchased in 1981 (no. 15). The Baron's first acquisitions of 20th century art had been paintings by the Expressionists in Germany.

Once again we are fortunate that Baron Thyssen-Bornemisza has agreed to share his paintings with the American public. Because of their vulnerability to light, no drawings have been included, and, like the previous selection of his Old Masters, these sixty-six paintings represent only a fraction of the Baron's holdings.

Graciously, and with only one exception, he has allowed me to make a personal choice, and any faults of omission are mine and not his. His particular interests as well as his broad range of taste, however, are clearly indicated. And, from the acquisitions that the Baron has made during the few months since this selection was determined, another exhibition could be presented. The collection itself is housed not only in his private apartment in Lugano but in various residences around the world.

In the preparation of this preliminary guide, I wish first to thank Baron Thyssen-Bornemisza for his gracious and enthusiastic cooperation. Without the assistance of Simon de Pury, Curator of the Baron's collection, no paintings or reproductions would be at hand. Derek Birdsall, the designer of this catalogue, has been at every stage my collaborator, and I hope very much to work with him once again. I also wish to thank Anne M. Lantzius, Lisa M. Messinger, and Janet M. Walker for their very real contributions as well as their patience.

William S. Lieberman

20th Century Masters: the Thyssen-Bornemisza Collection by William S. Lieberman

1
André Derain (1880–1954)
London, Waterloo Bridge 1905–6
Oil on canvas
31 ½ × 39 ¾ in. (80.5 × 101 cm.)

The essential *Fauve* painters are Henri Matisse, André Derain, and Maurice Vlaminck. Matisse was the eldest; between him and Vlaminck, Derain was the link. Their artistic kinship lasted scarcely three years.

On his first visit to London in 1905, Derain continued Matisse's adaptation of a Neo-Impressionist method of painting in a series of spectacular views of the Thames, its bridges, boats, and embankments. *Waterloo Bridge* (not the bridge of today) is characteristic.

The staccato mosaic of irregular blocks of color derives from the smaller, more exact markings devised earlier by Seurat. In 1905, however, the Pointillist method was better known to the *Fauve* painters through the examples of Paul Signac and Henri-Edmond Cross.

Derain's spaced brushstrokes are freely applied. A pyrotechnic display, the variegated and changing yellows (emanating from an unseen sun) burst and cascade above the dark blue silhouette of the bridge (the painting's horizon). Complementary to both yellow and blue are the green waves of the tidal river. All color is arbitrary.

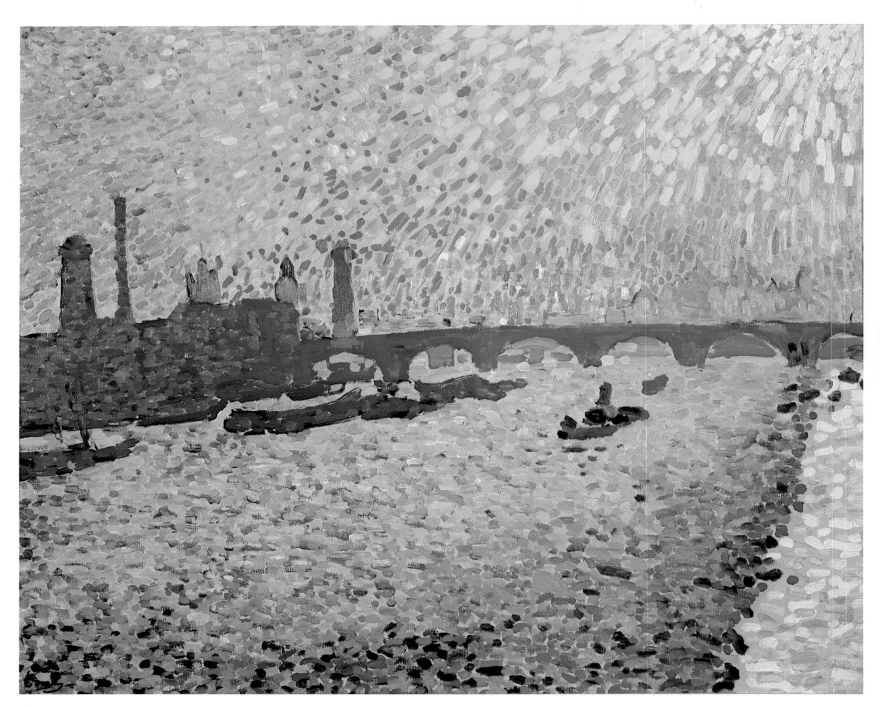

Vlaminck also exploits a similar divisionist method of applying color, but with brushstrokes that are more abrupt and impetuous than those of Derain. Displaced and less dense, they are painted thickly, almost in relief. Vlaminck's composition, as well as his subject (a worker in a field), owes much to van Gogh whose exhibition in Paris in 1901 had been attended and studied by the three *Fauve* painters. Vlaminck's painting has been traditionally titled *The Olive Trees*. If he indeed visited the South of France in 1906, such a visit is unrecorded. The landscape here is more probably near Chatou, not far from Paris, where for a time Vlaminck and Derain, and at least on one occasion, Matisse, painted together. Vlaminck's expression is direct, even graceless. The tilting earth flows allow only a glimpse of sky. The tree, a dark silhouette that dominates the picture, stands starkly in the foreground.

Neither Derain's river view nor Vlaminck's tilled field indicates that the *Fauve* painters would soon abandon a divisionist method, and that under the influence of Gauguin, their style would adopt flatter and more rhythmic patterns often celebrating a golden age, a primitive and pastoral ideal.

2
Maurice Vlaminck (1876–1958)
The Olive Trees 1905–6
Oil on canvas
21 × 25⅝in. (53.5 × 65cm.)

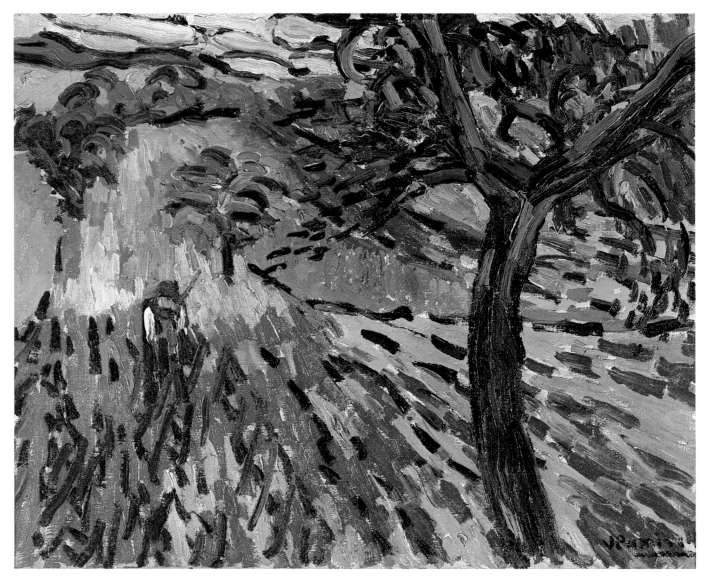

3
Pablo Picasso (1881–1973)
The Harvesters 1907
Oil on canvas
25½ × 32in. (65 × 81.3cm.)

The Harvesters is one of several major paintings by Picasso collected by Nelson A. Rockefeller. When these were shown together for the first time at the Museum of Modern Art in 1969, *The Harvesters* was the earliest and least known. Like *Les Desmoiselles d'Avignon* painted in the same year, it is a transitional picture. It contains several unresolved elements, and spatial relationships in the foreground remain unclear. Picasso seems to have remembered vividly some incident that he had observed a year earlier in Gosol in the Andora valley. Indeed, the Thyssen-Bornemisza painting may be the first statement for a larger composition that was never realized.

Although many of its distortions indicate stylistic innovations that Picasso would develop during the next ten years, *The Harvesters* is not typical of its period nor should it be considered a proto-Cubist painting. Picasso, of course, was never pictorially associated with the *Fauve* painters, but his *Harvesters* could well be included in any exhibition of their work. The picture might also be considered a "joie de travail," a celebration of labor, and vis-à-vis Matisse's *Joie de Vivre*, finished and publicly shown the previous year. *Les Desmoiselles d'Avignon*, however, is much larger than *The Harvesters*, and with it Picasso created a formidable and audacious response to the earlier figure composition by Matisse.

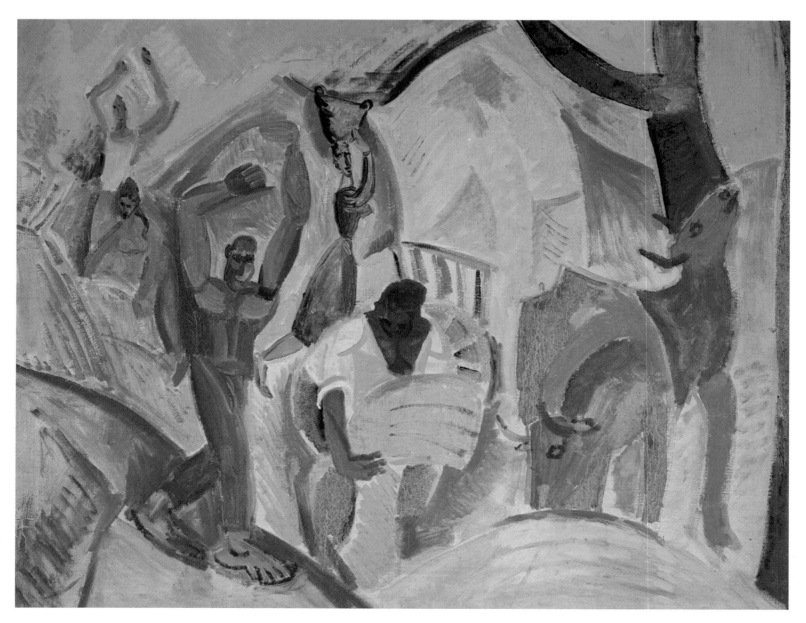

The harvesters are farm laborers, three men and one woman, gathering sheaves of hay to be packed into bales. A fifth figure, a woman, carries a green basket. The harvest that has been gathered is being stacked onto an already weighted wagon, and the load rises like a mountain. At the right, grazing, is the brace of oxen that will draw the haywain. One nibbles at a mound of grass, the other nuzzles against a tree similar in shape to the trunk in Vlaminck's landscape reproduced on the previous page. At the edge of the canvas, another tree is cut by the picture's frame.

In the summer of 1907, Picasso reworked and finished *Les Desmoiselles d'Avignon*. As with his mural *Guernica* painted thirty years later, he could not stop; and he continued to expand specific themes suggested by the larger picture that he had just completed. The raised arms of the *Nude* however, relate most closely to a similar composition more than twice its size, and sometimes called *The Dancer of Avignon*, a painting now owned by Basil Goulandris. The smaller painting reproduced here probably preceded the larger standing nude.

The background of the *Nude* seems completely abstract, and the body fills the format of the canvas. The impression of movement is vivid, even violent. The figure is seated on her heels, and we see both thighs, and at the lower left, one foot. The pose and the linear patterns recall African wood carvings and their scarifications, in particular those of the Yoruba people of Nigeria and the Luba of Zaire. The raised arms, bent level to the head, specifically relate to Luba caryatids that support the seats of stools and headrests. Picasso thus synthesizes several impressions from different African cultures. In the larger painting, Picasso actually incised and scratched lines into the surface of the paint.

On Easter Monday in 1969 in Sussex, Roland Penrose was notified of the theft of some twenty modern paintings from his London flat. Among these was Picasso's *Nude*. Held for ransom, all the pictures were eventually recovered. The thieves, however, had slashed the top right corner of *Nude*, and they had mailed Picasso's signature to the owner as intimidating proof of their theft. The damage was repaired, and in his recent memoir *Scrapbook*, Sir Roland gives a lively account of Picasso's contribution to the restoration.

4
Pablo Picasso
Nude with Arms Raised 1907
Oil on canvas
24⅞ × 16¾ in. (63 × 42.5cm.)

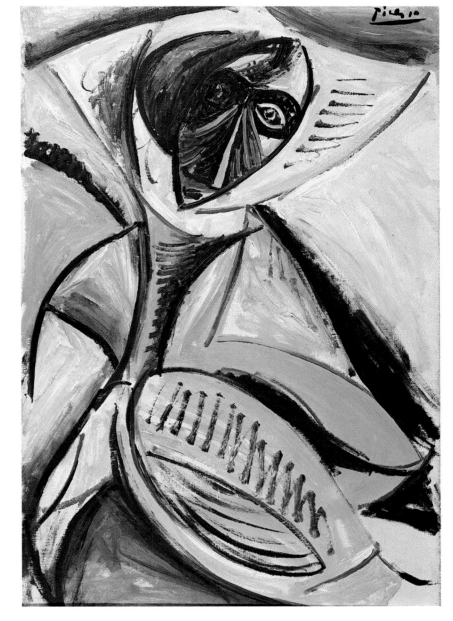

Karl Schmidt-Rottluff (1884–1976)
Autumn Landscape at Oldenburg 1907
Oil on canvas
29½ × 38¼ in. (75 × 97 cm.)

In Dresden in 1905, four young students of architecture, Ernst Ludwig Kirchner (p. 16), Karl Schmidt-Rottluff, Erich Heckel, and Fritz Bleyl, decided that their principal interest was painting. They banded together and, perhaps inspired by Nietzsche, called themselves *Die Brücke*, in English "The Bridge." Bleyl quit the group. The remaining three were soon, but briefly, joined by Emil Nolde (p. 20), and later, but for longer, by other German painters of less distinction.

The painters of the *Brücke* constituted the first group of German Expressionists, and they were a small but articulate avant-garde against the prevailing establishment. Opposed to genre as well as to romantic painting, they also believed that Impressionism had become academic and that Symbolism had grown stale. The *Brücke* artists considered themselves revolutionaries. They shared a bohemian life, and in the first years of their association, they sought an idyllic Arcadia in a contemporary world. The young artists saw themselves as the bridge between man and nature, between life and art. Their method of painting, like the expression of their emotions, was direct, even harsh. In 1911 the *Brücke* artists moved to Berlin. Kirchner remained the dominant personality, but the First World War soon brought an end to their almost daily association.

All *Brücke* artists were prolific as printmakers, and from the outset, printmaking was as important as painting to their program. In the woodcut, a medium that inherently combines strength and decoration, they found the most successful means of expressing the coarse vitality of their related styles. In turn, the carved and printed medium contributed vigor, boldness and a simplicity of design to their painting.

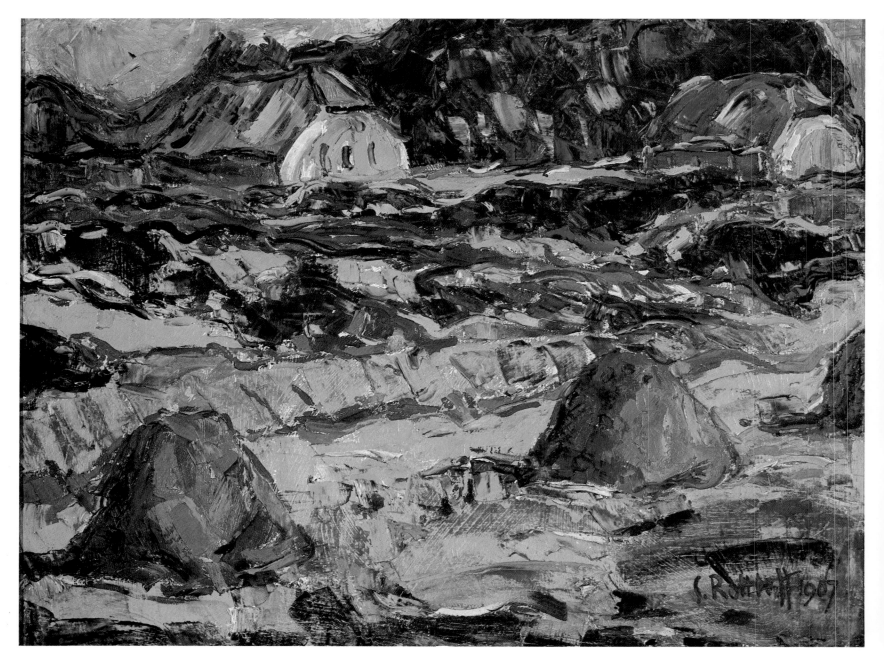

The formation of the *Brücke* in 1905 coincides in time with the looser, less doctrinaire association of the *Fauve* painters in France. The characteristic style of the German artists, however, developed somewhat later. Both groups of artists were influenced by Post-Impressionism and by Primitive Art. Both exaggerated, for expressive purposes, unnatural color and bold distortion of form. The longer, more intimate association of the *Brücke* lent cohesion to their brotherhood, a relationship that the *Fauve* painters neither attempted nor desired.

Schmidt-Rottluff and Heckel spent the summers of 1907 and 1908 together, and they painted in the Dangast moor country located in Oldenburg near the North Sea. These two landscapes in the Thyssen-Bornemisza Collection show specific views of the region, and, as is clearly apparent, the interpretations of both artists owe much to van Gogh as well as to Edvard Munch.

In Schmidt-Rottluff's autumnal scene, the harvesters' work is done. Space recedes along irregular bands between the haystacks in the foreground and the parallel cluster of houses, trees, and sky. The impasto on the canvas is built by heavy overpainting, roughly applied in broad strokes and sometimes even scratched. The pulsating colors of the field are complemented by the blue accents of the background.

Heckel's view may seem similar in interpretation. His colors, however, converge on a single element, the white house, and the curving country road leads directly to it. Heckel more clearly outlines the contours of forms, his colors are less blended, and his much sparser application of paint does not completely cover the canvas.

6
Erich Heckel (1883–1970)
The White House 1908
Oil on canvas
28⅜ × 31⅞in. (72 × 81cm.)

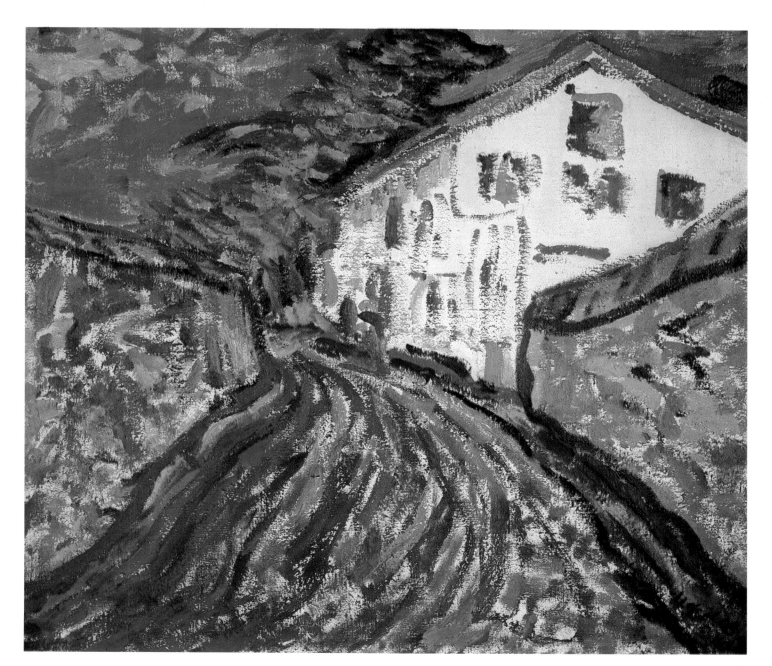

7
Ernst Ludwig Kirchner (1880–1938)
Franzi before a Carved Stool 1910
Oil on canvas
27¾ × 19⅝ in. (70.5 × 50cm.)

At first glance, Kirchner's painting seems to be a double portrait which, in fact, it is not. Looking directly at the painter, her lover, sits Franzi the younger of two orphaned girls who lived with the *Brücke* artists before the "brotherhood" quit Dresden and moved to Berlin. The second figure is actually an extraordinary piece of furniture designed by Kirchner, carved and then painted in the form of a crouching woman. Although this "home-made" idol was intended by Kirchner to reflect his early enthusiasm for Primitive Art, it does not seem to relate to any specific prototype of African sculpture that he may have studied in Dresden's Ethnographic Museum. In an attempt to emulate the directness of Primitive expression, however, Kirchner carved several other pieces of household furniture as well as single standing figures in wood.

Within the frame of the portrait, and with the sitter off center, space is contracted. The configuration of child and carving is frontal, interrupting the diagonal thrust that crosses the composition. The inclining blue is the studio's floor. The decorative pattern of the abrupt background is another larger painting by Kirchner, angled against a wall. Perhaps a representation of bathers by a lake, only a lower portion of this second painting is revealed. The device of a picture within a picture would be exploited by Matisse in his own studio a year or two later.

An acid, unnaturalistic yellow-green colors Franzi's face. Gashes of red line her eyes, paint her over-ripe lips, and define one ear. Blue, then complementary strokes of pink and green model other features. It is difficult to believe that the inspiration for this mask was a child of only a dozen years.

With its high neck, patterned cloth, and decorative ornament, Franzi's dress is a mixture of "grown-up" provincial styles. Her expression seems bemused if not unknowing, and she appears completely unaware of the animated figure behind her. The anatomical details of the carving are concealed. Nevertheless it looks naked and its attitude wanton. The naturalistic flesh tone is unexpected, the grimace suggests frenzy, and the blocked hair contrasts with Franzi's own. Does the juxtaposition suggest dual aspects of the pubescent girl?

The painting at the right admirably illustrates the first and more expressive of Jawlensky's two mature styles. He seldom painted the figure full, and, characteristically, head, neck and shoulders curve to fit the rectangle of the canvas. Forms are flattened; illusionistic perspective does not exist. As in the portrait by Kirchner, the view is frontal; Jawlensky's colors are also discordant, their vividness heightened by rhythmic outlines in black. Unlike the portrait by Kirchner, the effect is neither disturbing nor harsh. Indeed, in translation, Jawlensky's adaptation of late Byzantine gestural stylization seems sentimental. The contour of the woman's head scarf, too solid to be a veil, haloes and softens the flattened angularity of the features.

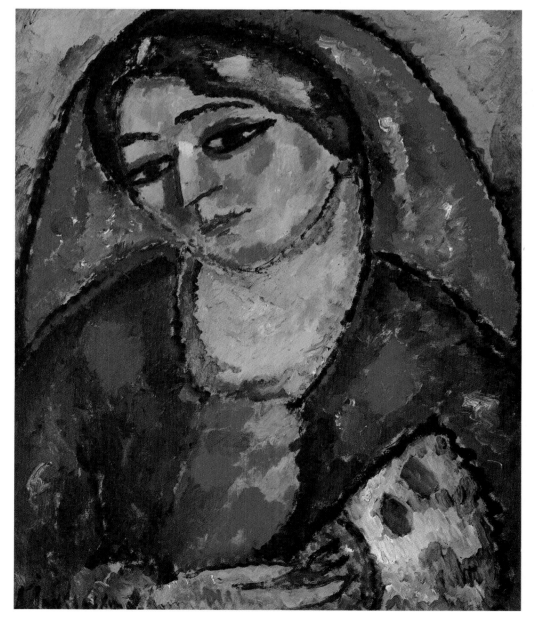

Maurice Prendergast (1859–1924)
Autumn 1910–12
Oil on canvas
19¼ × 24⅜ in. (49 × 62cm.)

In the future, the American artist Maurice Prendergast may be esteemed more for his works on paper than for his larger paintings on canvas. His watercolors and monotypes breathe freshness. His impressions are vivid, his observations specific, and his response is immediate, usually dazzling in its description. Also, in both watercolor and monotype, Prendergast exploited as a color the white of the paper itself.

The precise dating of Prendergast's paintings in oil is difficult to establish. During the last dozen years of his life, however, he returned to painting on canvas, and he drew increasingly less on paper. These later paintings, opaque in color and horizontal in format, lack luminosity. Their subjects are generalized, and they often assume the burden of allegory. Spontaneity, inherent in the volatile media of watercolor and monotype of which Prendergast had been a master, surrendered to formal arrangements contrived in the studio.

Autumn, probably finished slightly later than its usually assigned date, is a capital example of Prendergast's decorative style. The theme is idyllic, and the composition is dense. Space is flattened into a frieze that integrates figures and trees into a patterned mosaic. The knitted colors are worked and reworked, effecting a thick porous surface of paint that encrusts the entire canvas. The women and children, it should be noted, are dressed in shades appropriate to that season so special to New England. Today Prendergast is usually considered one of the early American "modernists." His pastorals, however, have little to do with the everyday life with which those painters were chiefly concerned. Even Prendergast's views of Central Park evoke Arcadia.

The German painter Franz Marc, a younger artist, was not content with landscapes of pleasure. He sought to emphasize and nourish basic universal values, spiritual in their purity and religious in their intensity. He believed that lyric creation was exalted and essential, and that it transcended the anxieties of an industrial age to give meaning to contemporary life. It was precisely because of these beliefs that he and Wassily Kandinsky, a Russian, founded "The Blue Rider" (*Der Blaue Reiter*) in Bavaria in 1911.

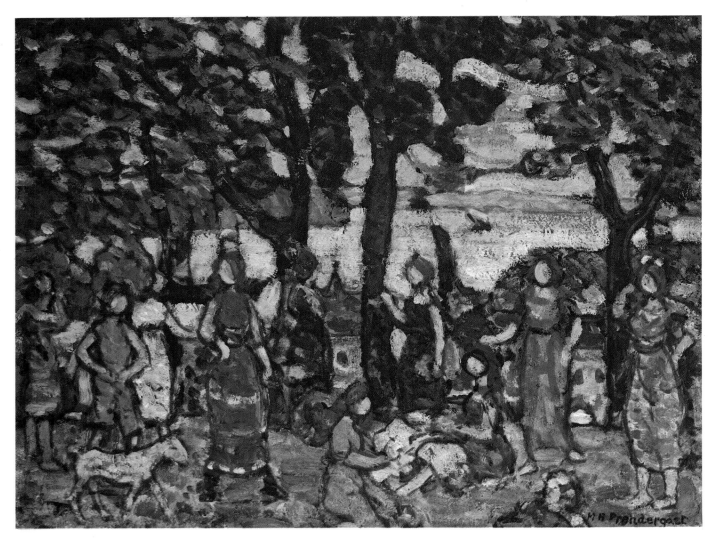

Kandinsky broke with visible reality and invented a visual language that became abstraction. Marc remained faithful to representational expression, and he created a Peaceable Kingdom, a world of animals where he projected his own human aspirations for goodness, innocence, and harmony. "The still virgin sense of life possessed by animals awoke in me all that is noblest." The First World War, however, abruptly shattered his dreams. His visions became apocalyptic, and in that cataclysm he died.

The elements of allegory in *The Dream* are not completely resolved. It seems a sincere but naive folk tale that has assumed the authority of legend. At the left, painted yellow, is the real world: a house, his own, and a lion, less likely, whose roar goes unheard. The remaining scene is the dream, brilliantly colored although the sky is black and the time is night. The nude, modestly if awkwardly posed, is asleep or in reverie. Seated by a stream, a traditional symbol of purity, she is protected by two horses. Their color blue, Marc believed, was the most important of the primaries and, for him, it represented virility, intellect, and peace. The diminishing repetitions of pose and contour are characteristic of Marc's style.

In Marc's most successful paintings and woodcuts human beings do not appear. *The Dream*, however, celebrates his recent marriage. One of his largest compositions, it was originally owned by his close friend Kandinsky.

10
Franz Marc (1880–1916)
The Dream 1912
Oil on canvas
39½ × 53⅜in. (100.5 × 135.5cm.)

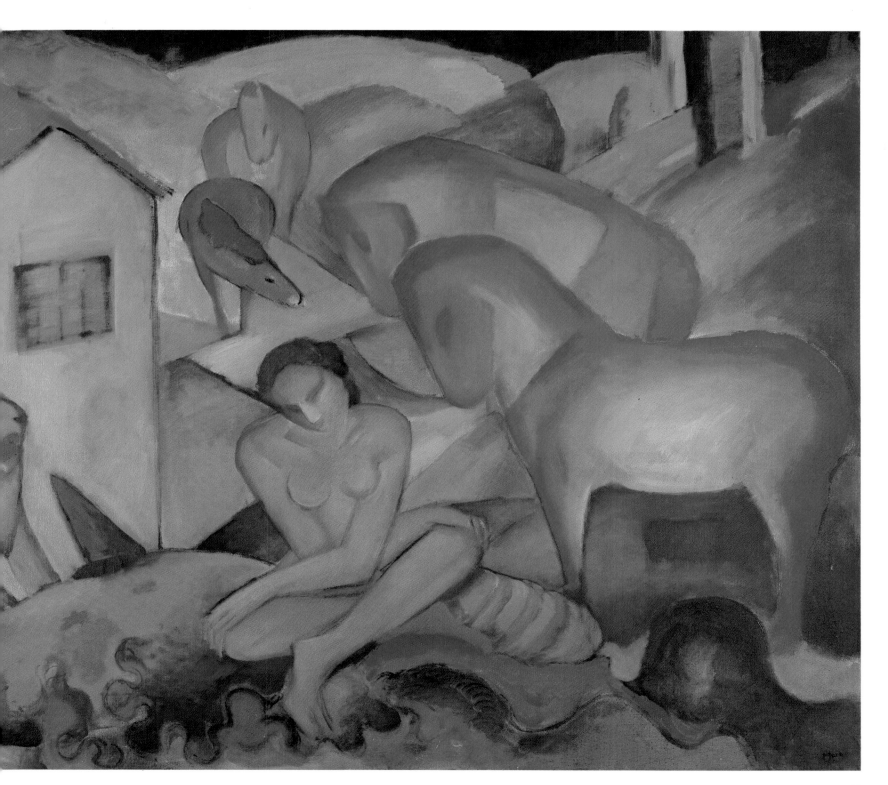

11
Emil Nolde (1867—1956)
Flower Garden 1917
Oil on canvas
32¼ × 25½ in. (82 × 65cm.)

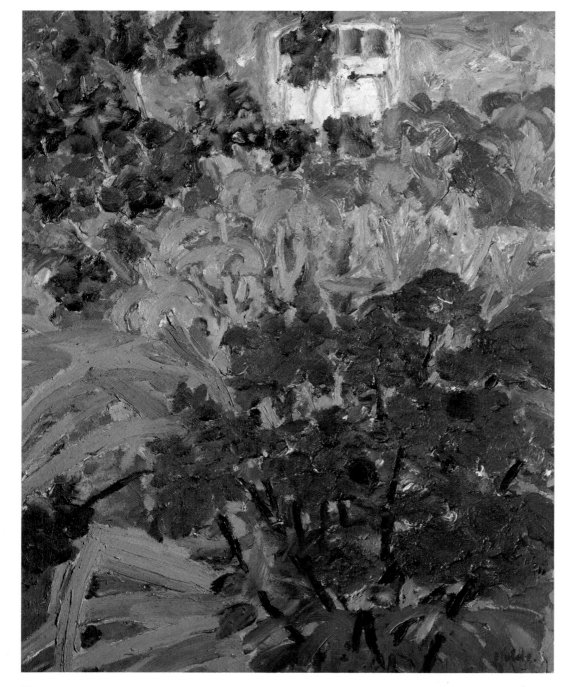

Emil Nolde was a solitary artist and a lonely man. He was convinced that his vision was Aryan, and he was therefore confounded when his own work was condemned by the Nazis who rejected his approaches and then forbade him to paint. Luckily, and for many years, he had already found refuge in the harsh landscape abutting the Danish border. In its dramatic clouds and seas, and in his own domesticated garden, he found direct communication with the life forces of nature. His *Flower Garden*, a landscape of pleasure, was perhaps his only real happiness.

Nolde's most dramatic paintings are scenes from the life of Christ, and unexpectedly, brutish images of peasants whose faces he vividly remembered from a long train journey across intercontinental Russia in 1913. These paintings in oil, however, lack the deft directness of his watercolors, and only his paintings of flowers match the quick observation and grace of his watercolors on paper.

Nolde was the elder of Kirchner, Heckel, and Schmidt-Rottluff. He was flattered by their praise but in no way did he wish to assume leadership in the Expressionist avant-garde. His formal association with the *Brücke* in 1906 was brief. Nevertheless these few months occurred during the formative years of the *Brücke* in Dresden. It was Schmidt-Rottluff who had invited him to join the brotherhood, and both artists were deeply religious in their Christian faith.

Printmaking was integral to the program of the *Brücke*, and it is through the younger artists that Nolde developed an interest in etching, lithography, and woodcut. As a printmaker he was prolific, and the variety of subjects in his graphic oeuvre is much greater than in his paintings and watercolors. In printmaking he found his most eloquent and boldest expression.

In 1913, before the age of thirty, Max Beckmann was successful as an artist and financially secure. His exuberant style came from Impressionism, and it anticipated the virtuosic brushwork that Lovis Corinth, his elder, developed a decade later. Beckmann's portraits and paintings of historical events (including the sinking of the *Titanic*) attracted clients and critics. In addition, a monograph had been devoted to his art, and in 1913 his one-man show in Berlin closed with only one painting unsold. The First World War, however, traumatized Beckmann's life and art.

As an orderly in the medical corps, Beckmann was an hourly witness to carnage. The continuing horror overwhelmed him, and in 1915 he collapsed and was discharged from the army. When he recovered, his vision had changed, and he also saw more deeply. He painted Biblical scenes and subjects of despair of which *The Night* (1918—19) in the collection of the Nordrhein-Westfalen Museum in Dusseldorf is the most famous.

During the 1920s, he realized more contemporary allegories, and his subjects were the contrasts of postwar Germany. Beckmann considered himself an observer, and his most frequent image was his own likeness. He saw the world as a tragedy of man's inhumanity to man. He saw life as a carnival in which human folly continues.

During the early 1920s, the tightness of Beckmann's new style, his sharp focus and the exactness of his characterizations seemed similar to the precise definitions of the new German realists (nos. 47, 48). Although he exhibited with them at Mannheim in 1925, he never adjusted to their rigid formula. Indeed, he refrained from joining any group of artists. In the same year he and his first wife divorced. He married Mathilde ("Quappi") von Kaulbach, a musician and a beautiful woman of extraordinary sensibility, who remained his companion for the rest of his life. Beckmann's attitude in his painting became less bitter and his forms less rigid. His subjects were happier and they glowed with color. *Clown and Pierrette* (1925), an allegory of himself and Quappi in the collection of the Kunsthalle in Mannheim, introduces this new phase in his development. Quappi's pose is similar to that in her later portrait in the Thyssen-Bornemisza Collection, but she is dressed in blue and in her right hand she holds a fan instead of a cigarette.

Quappi in Rose was begun in 1932 and was finished two years later. During the interval another calamity transformed Beckmann's life. The Nazis had forced him to surrender his professorship at the Academy in Frankfurt, and he and his wife had moved to Berlin. The portrait in the Thyssen-Bornemisza Collection gives no indication of their dislocation. Instead it celebrates conjugal love. Also, the portrait may have offered respite from his more arduous effort in the painting of the first of his nine allegorical triptychs, *Departure*, which is now in the collection of the Museum of Modern Art. Quappi, as consort, appears in the central panel of the triptych, and Beckmann described its narrative: "King and Queen have made themselves free, free from the torments of life which they have overcome. The Queen carries the greatest treasure, freedom, as her child in her lap. Freedom is all that matters: it is Departure, the new beginning."

The "new beginning," however, was soon cut short; and the left and right panels of the triptych, both scenes of torture, were more prophetic. In July 1937 in Munich the Nazis sponsored an exhibition of "degenerate art," works by modern masters confiscated from German museums. Paintings by Beckmann were featured, and he and his art were publicly condemned. On the very day the exhibition opened, he and Quappi fled to Amsterdam. Thirteen years later he died in New York, the greatest allegorical painter of our century.

12
Max Beckmann (1884–1950)
Quappi in Rose 1934
Oil on canvas
41 3/8 × 28 3/4 in. (105 × 73cm.)

CHAPTER TWO: Abstraction

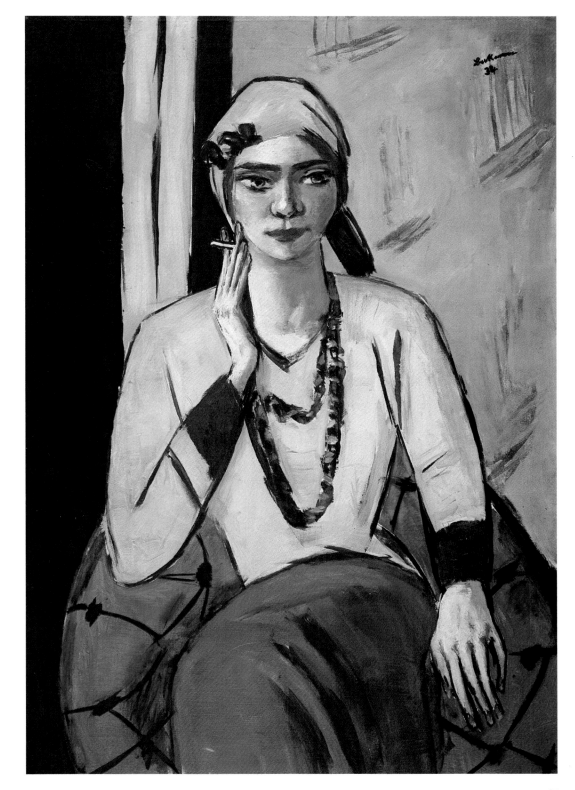

13
Frantisek Kupka (1871–1957)
The Language of Verticals 1911
Oil on canvas
30¾ × 24¾ in. (78 × 63cm.)

The first abstract pictures were painted shortly after 1910 by Frantisek Kupka, a Czech in France, and Wassily Kandinsky, a Russian in Bavaria. Their previous paintings had been descriptive, and their subjects, narrative and, in retrospect, sometimes trite.

At the time, neither painter knew the other, and neither self-consciously decided to renounce naturalistic representation. Both Kupka and Kandinsky, nevertheless, swiftly evolved a new pictorial language, spiritual in intent, emotional in expression, and abstract in effect. Such dramatic images derived from Symbolism, and both Kupka and Kandinsky, it should be remembered, associated painting with the sound and rhythm of music.

Kupka's abstractions, in Paris, were inspired by the architecture of Gothic cathedrals, in particular the stained glass of their windows and the slender, closely massed columns that supported their interiors. Although his studies derive from perceptual reality, any demonstrable relationship to original motifs vanishes in translation into pictorial terms. In Kupka's small painting, the dominant chords of color are pink against red, the former more striated. The shorter verticals, suspended from above, are situated nearer to the picture's plane. Below and set diagonally, the parallel and stronger progressions, dominately green, combine with bands of black to create an open grid from which rise the tall, clustered perpendiculars. The overall pattern moves up and down. As this cascade shifts, its crescendos suggest the resonance of organ pipes.

Kupka worked sequentially. He developed similar movements in several other studies on the same theme of verticals. Kandinsky's paintings of this time are less repetitive. Their bursting spontaneity contrasts with the architectonic, decoratively insistent accents of Kupka.

In Kandinsky's *Painting with Three Spots* (a descriptive rather than a cognitive title), layers of large cumulous forms of different shades float diagonally upward and loosely fill the rectangle of the composition. Within them, three denser and flatter forms — red, blue, and green (the picture's spots) — have more definite outlines. These three shapes are festooned with swirling and straight ribbons of color, and their surfaces are scratched by a staccato of thinner, shorter lines.

Kandinsky's painting is one of eight completed in 1914 in Munich before he returned to Moscow at the end of that year. Each is spontaneous in effect, each suggests a state of mind, and all share bright colors as well as a similar dynamic structure of free interrelated forms. The focus of the Thyssen-Bornemisza picture — the area of red — is off center. Three prongs thrust from the lower left, and their diagonal direction is enhanced by the thin lance of blue cutting across the three ovoid forms. Kandinsky always associated the number three with the divine, as in the Trinity.

In Kandinsky's painting is the birth of the world, a mass torn from the cosmos. Here also is the birth of a new language of vision.

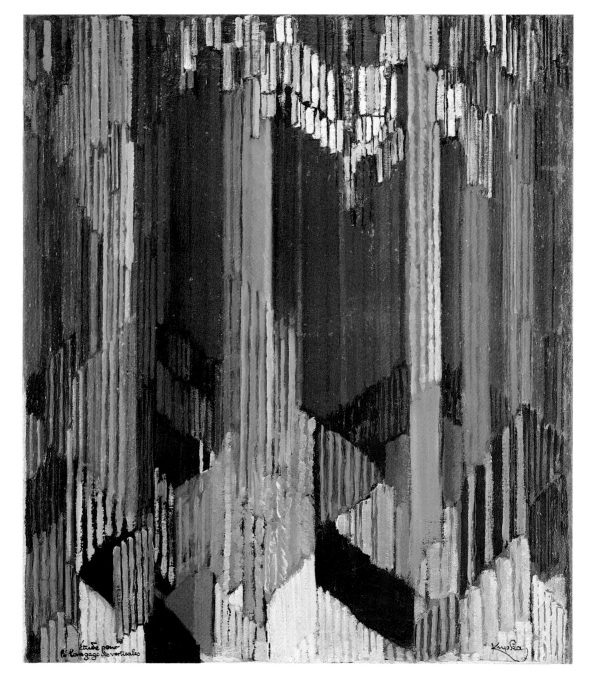

14
Wassily Kandinsky (1866–1944)
Painting with Three Spots 1914
Oil on canvas
47⅝ × 43¾ in. (121 × 111 cm.)

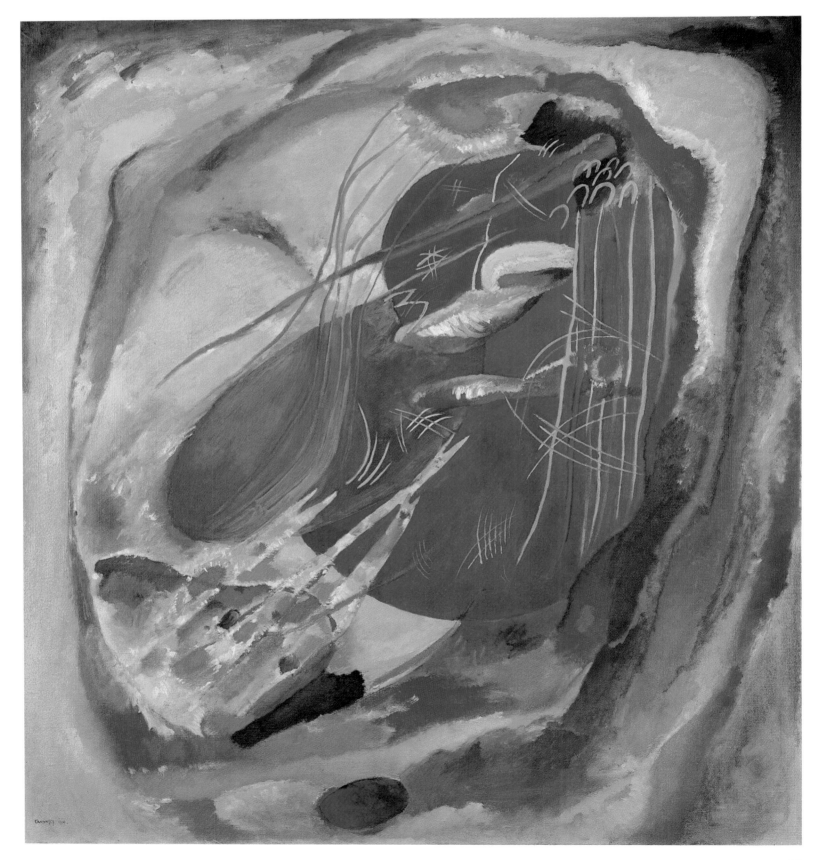

15
Gino Severini (1883–1966)

Expansion de la Lumière 1912
Oil on canvas
26⅞ × 17in. (68.5 × 43.2cm.)

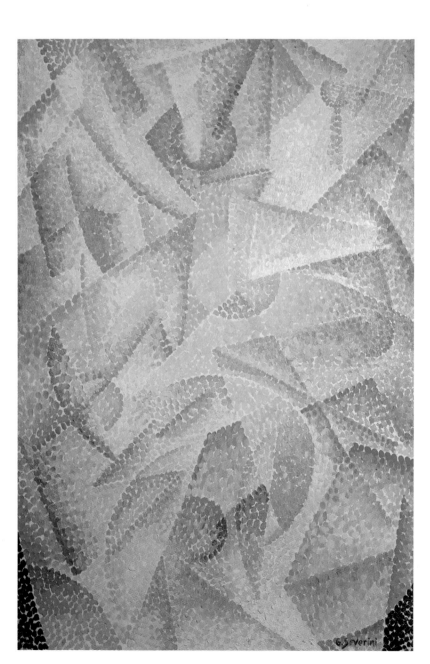

Before the First World War and throughout the capitals of Europe, an insistent bombast promoted an Italianate, self-congratulatory response to Cubism. "Futurism," as a word, had been originated by the poet Filippo Tomasso Marinetti to identify the modernity of his own writings. What he had conceived as a literary phenomenon, however, rapidly expanded into an artistic movement.

In 1910, on stage and in print, five Italian painters joined together to issue their own Futurist proclamations. These five painters were Giacomo Balla, Umberto Boccioni, Carlo Carrà, Luigi Russolo, and Gino Severini. Marinetti remained their literary counterpart, but the visual impact of their paintings reached a wider audience. Futurism, as a style, popularized Cubism and added to it motion and dramatic effect. Boccioni was its chief spokesman, Balla its senior artist, and Severini its man about Paris.

The subject matter of the Cubist painters in France was contained within their studios. Their method was lucid, analytic, and essentially contemplative. They seldom, if ever, propagandized their own art. The Futurists, however, were concerned with the world outside. They were activists and they demanded an audience. They developed a specific attitude based upon urban life and upon modern technological advance. To them progress was power, dynamism, and light, and their images are charged with emotion and, sometimes, political awareness. In retrospect, Futurist practice continued Symbolist theory. At the time, however, Futurist painting seemed brash, new, and even revolutionary. Its influence spread noisily throughout the continent, particularly to Russia, and to England and America.

During his Futurist association, Severini lived principally in Paris where he enjoyed and celebrated the music hall pleasures of its nocturnal life. Many of his compositions are infused with a lively sense of gaiety. During 1913–14, he progressed further towards abstraction, and he developed a lyric sequence that seems a jubilant hymn to light itself. The series' title, *Spherical Expansion of Light*, suggests his belief that light was "the plastic absolute," a universal force, and an energy that expanded in space and that linked all matter. These "spherical expansions," all graceful in their turbulence, derive from single figures dancing. Their individual aspects are obscured; Severini is interested only in the centrifugal turbulence of their motions. The rhythms are painted in bright luminous colors applied to the canvas in a divisionist technique. The concentration of yellow at the center represents the source of radiating energy, the movements of a dancer transformed into light.

Somewhat petulantly, the Futurists declined to participate in New York's Armory Show of 1913. Severini, however, contributed fourteen paintings to the Panama-Pacific International Exhibition held in San Francisco in 1915.

Balla's *Demonstration* is also one in a series of compositions on a single theme. The tonalities of Balla's painting, however, are darker, and they contrast to the elevating lightness of Severini's staccato sensations. Movement is lateral, and flowing bands of color wave through the horizontal composition. Balla's subject is topical. Frequent demonstrations in the streets of Rome urged Italy to join the Allies in declaring war on Austria, a decision finally made in May 1915. Balla synthesizes his impressions of a political rally, its tumult and its banners. His colors are those of the new Italian flag, red, white and green. In addition, it has been suggested that the figure 8 at the vortex may be interpreted as an emblem of the House of Savoy whose head, Italy's king, was a committed interventionist.

Four smaller works on paper relate to Balla's painting in the Thyssen-Bornemisza Collection. One of these, in tempera, is titled in Italian *Sventolamento*, a literal description of the swirling arcs and billowing flags. The three other studies, each a collage, bear the title of the final version.

Deaths and dislocations during the First World War dissolved the cohesiveness of the Futurist group. Only Balla, the teacher of Boccioni and Severini, remained faithful to its tradition.

16
Giacomo Balla (1871–1958)
Patriotic Demonstration 1915
Oil on canvas
39⅜ × 53¾ in. (100 × 136.5cm.)

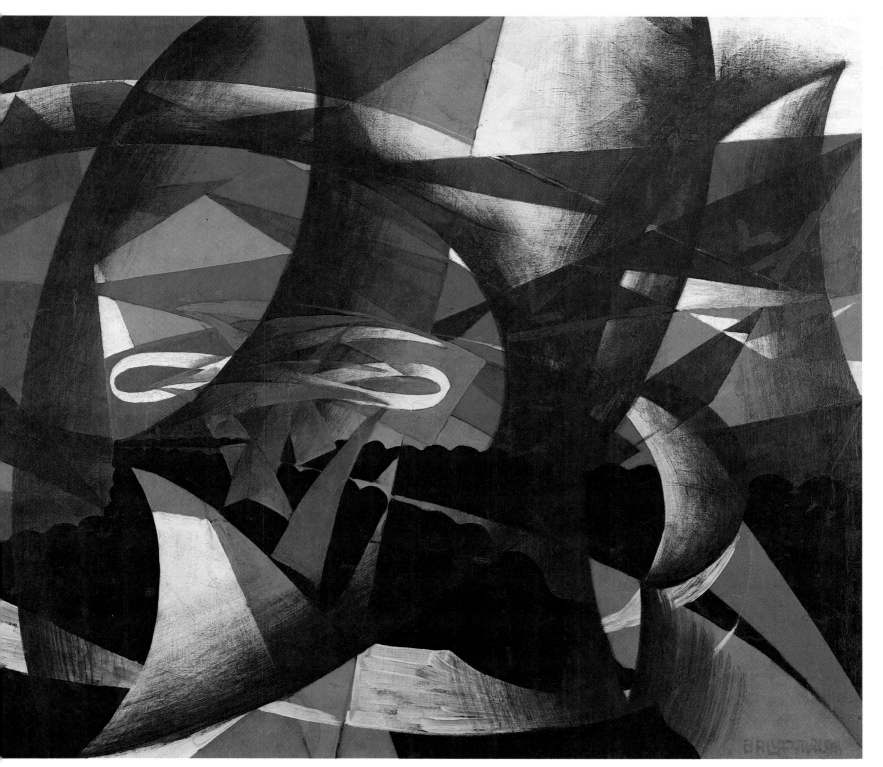

17
Natalia Gontcharova (1881–1962)
Rayonist Composition 1912–14
Oil on paper on cardboard
19 1/4 × 25 1/4 in. (49 × 64cm.)

The Russian avant-garde was a composite of small, frequently antagonistic groups, each of which considered itself correct and all others wrong. What these artists did share was a commitment to abstraction and experiment. This commitment was unrelated to the free improvisations of Wassily Kandinsky, their compatriot in Munich. It derived instead from Cubist analysis, although neither Braque nor Picasso ever painted a non-representational picture, and from Futurist emphasis on movement in space. Also, with a few exceptions such as Gontcharova, the artists of the Russian avant-garde sought to establish in visual terms an ideal world supported by scientific discovery and social progress.

In France and in Italy, no female assisted at the birth of either Cubism or Futurism. However, in Russia, and from the outset, women played a dominant role in all phases of the avant-garde. Natalia Gontcharova was among the first, but she belonged to the ancient regime. Liubov Popova was the archetype of the new.

Rayonism, a style of painting initiated by Mikail Larionov, was announced in publication and exhibition in Moscow in 1913. During the previous year he had developed in theory and in practice a method that considered not so much the object itself but rather straight rays of light which he imagined the object reflected. The painted results were compositions of crossing lines varying in color, length, and texture.

Gontcharova, Larionov's wife, and a finer artist, adopted for a time his Rayonist style. Her paintings usually retain some vestige of the original source. Her composition in the Thyssen-Bornemisza Collection does not. It simply portrays energetic patterns of movement. The strokes are strong and decisive. Paths of brilliant color converge to generate a diagonally accented vortex that strains against the imposed boundaries of the rectangle. No other painting better expresses the Rayonist style. In 1914 Gontcharova and Larionov left Moscow to join Diaghilev and his ballet company in Paris, where they permanently settled in 1917. Neither witnessed the full development of the avant-garde in Russia.

Liubov Popova, in her early twenties and before she visited Paris, was already an accomplished artist. Her early paintings, influenced by Impressionism and Matisse, are filled with light and are bold in their composition. Her early drawings are vivid and selective in their observation of the human face and figure.

In Paris during the winter of 1912–13 and again in 1914, Popova was aware of the advances of Braque and Picasso but she had no direct contact with either painter. Instead she knew Cubism second hand and studied with two less inspired artists, Jean Metzinger and Henri Le Fauconier. She also saw and certainly studied Futurist painting, drawing and sculpture by Boccioni. Upon her return to Moscow, she resumed contact with Tatlin, himself influenced by Picasso's three-dimensional Cubist constructions. However varied, these influences were not disparate. In an extraordinarily short time, between 1914 and 1916, Popova developed a personal style that synthesized Cubist analysis and Futurist dynamism. ("Cubo-Futurismo," a dreadful expression, was a term frequently heard and actually lettered by artists in Moscow.)

Unlike the Cubist painters and their followers such as Metzinger, Popova did not remain content to concentrate on single, central motifs. In 1917 she began to develop overall compositions where planar projections of defined but non-representational shapes intersected and intercepted each other at oblique angles. These images are highly structured, and the interaction of their forms implies movement. Popova called them "painterly architectonics." She also made no effort to conceal her method of applying paint. Indeed Popova believed that tactile "texture is the content of painterly surfaces."

In the early 1920s, Popova redirected her art to the requirement of the Soviet regime. She created theatrical sets that were mobile in their design and that even today appear startlingly innovative. She also excelled as a typographer, and in her last few years turned her attention to the design of fabrics and clothing. In 1924 in Moscow she died of scarlet fever. She was not yet thirty-five.

18
Liubov Popova (1889–1924)
Pictorial Architectonic 1918
Oil on canvas
17¾ × 20⅞ in. (45 × 53cm.)

19

Gustav Klucis (1895–1944)

Axiometric Painting c.1920
Oil on canvas
26 × 18¾ in. (66 × 47.5cm.)

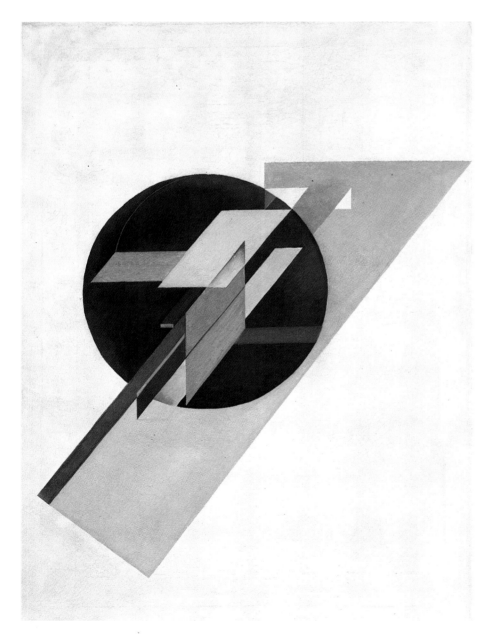

Before they met in Moscow in 1918, Gustav Klucis had already been influenced by Kasimir Malevich's earlier, representational Cubist style. As his student, Klucis assimilated the more recent developments of Malevich's painting, particularly his first Suprematist compositions of 1915–16. In Moscow, Klucis also knew the brothers Antoine Pevsner and Naum Gabo, both sculptors, and El Lissitsky, another of Malevich's pupils.

The title of Klucis's painting describes the theory of its composition. It was probably preceded by a photomontage and, possibly, a smaller gouache. The floating rectangles derive from Suprematism. Their structure, however, is complex; and the overlapping planes are organized on the same rigorously orthogonal principle exploited by Lissitzky.

The dark circle is individually characteristic and, like the earth, it is situated on a diagonal axis. Within the sphere are concentrated the other, shorter planes that interlock. The geometric shadow behind the circle strengthens the diagonal direction, and its pale color suggests a path in space. Klucis's treatment of rectangular elements is more architectural than that of Lissitzky, and a very similar painting by him is called *Dynamic City*.

Like so many of the Russian avant-garde, Klucis believed in the utopian potential of a technological age. During the decade of the 1920s, he increasingly dedicated his art to the service of the Revolution. His experiments in construction and in typographic design had practical results, and they met the increasing demands of political propaganda. In 1934 the Soviet Union proclaimed social realism its official style. A decade later, Klucis died in a forced labor camp.

In February 1920, Laszlo Moholy-Nagy, an Hungarian, arrived in Berlin. The Austro-Hungarian Empire had collapsed, and Berlin, even in defeat, was where the action was. Within a year Moholy had absorbed a variety of influences: Berlin Dada, particularly its collages and typographical experiments; Russian Constructivism and Dutch *De Stijl*, both of which reduced elements of composition to abstract forms independently articulated and asymmetrically placed; Italian Futurism with its emphasis on movement; and French Neo-Cubism as demonstrated by the mechanical themes and industrial landscapes of Fernand Léger. These several influences can be traced in his *Large Railway Picture*. All, however, have been completely assimilated, and Moholy speaks in his own authoritative idiom.

What is painted in Moholy's synthesis of a traveler's visual experiences is a train leaving a large railroad station: tracks, poles, gantries, barriers, signals, sheds, tunnels, and bridges. Moholy reduces these into a flat geometric pattern. Only the number "151" and the letters "E" and "R" are immediately recognizable. The number may designate a train or track; in German, *Eisenbahm* is the word for railway, *Reisender* that for traveler.

Klucis's *Axiometric Painting* and Moholy's *Railway Picture* belong to the same moment. Curiously, the Klucis composition anticipates the form and suggests the purpose of the *Light Machine* that Moholy would construct during the following years.

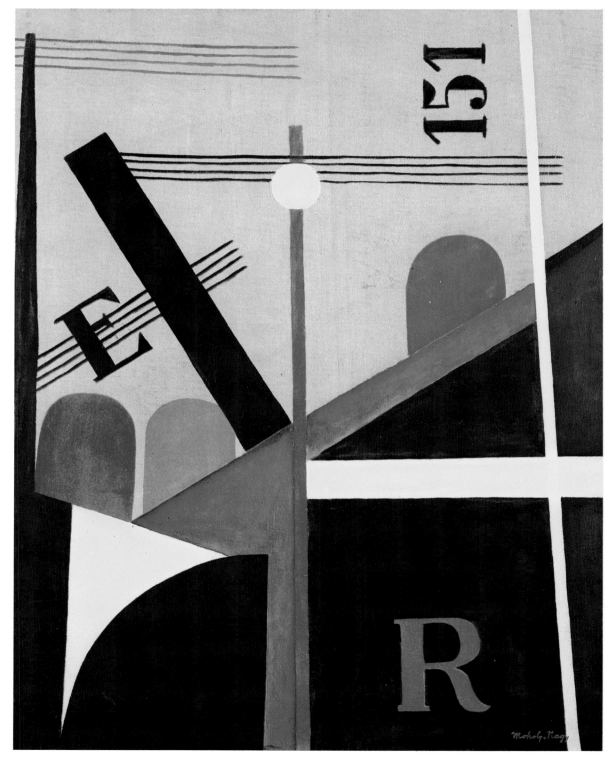

21
Lazar (El) Lissitzky (1890–1941)
Proun 4B 1919–20
Tempera on canvas
27½ × 21⅞ in. (69.8 × 55.4 cm.)

In 1918 Chagall quit wartime Paris and crossed Europe to return to Vitebsk, his homeland and even today the geographic center of his art. The former academic art school in Vitebsk had been transformed into an "Art Institute for the People," and Chagall was named its director. Surely he was proud; the city's ghetto had been his birthplace.

A year later, in 1919, Chagall selected El Lissitzky as an instructor in architecture and graphic design. Chagall was impressed by Lissitzky's technical qualifications, and he had also admired his animated illustrations to a rhymed Yiddish folk tale, the story of a goat. Chagall, however, was completely unprepared to accept Lissitzky's recent conversion to an abstract, theoretically revolutionary aesthetic. Their conflict was short, and it climaxed when Kasimir Malevich, apostle of non-objective art, arrived in Vitebsk. Chagall and Malevich shared a mutual dislike. Lissitzky, already inclined to Suprematist theory, sided with the latter. Chagall resigned. Malevich remained, and he achieved what he wanted, the directorship of the new cooperative school.

A few months later, Lissitzky invented the term "Proun," an acronym for Russian words reading "project for the affirmation of the new." Proun, he believed, identified his recent compositions; and these he considered as intermediate steps towards the construction of a different art transitionally situated between architecture and painting. Suprematism, he felt, was still limited to the format of the canvas and to traditional expression. Lissitzky saw himself as the "new" artist, a "constructor," and art itself as a "building process."

In his painting, Lissitzky successfully translated the flat planes of Suprematism into three dimensions by establishing precise, spatial relationships between each geometric element. His rectangular forms, usually defined in shallow depth, overlap. They can interpenetrate, and they can also suggest extension beyond the boundaries of the canvas itself. Such formal structures, Lissitzky sometimes thought, could be viewed from any side. The final solution to his Proun concept was actual architecture. Lissitzky created "demonstration spaces," complete and multi-directional environments that were exhibited in Germany during the 1920s.

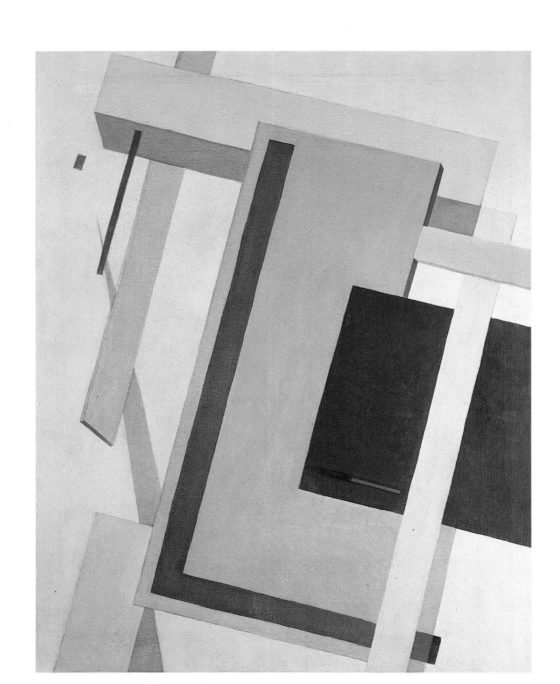

Ilia Chashnik, like Chagall and Lissitzky, spent his childhood in Vitebsk. At its Art Institute for the People, he became the prodigy of Suprematism, the youngest and the most dedicated of Malevich's adherents. In 1922 he followed the master to Petrograd and worked as a researcher in his "laboratory." In addition, Chashnik created crisp abstract designs, "affirmations of the new" in miniature, to decorate the traditional forms that the State Porcelain Factory in Petrograd continued to manufacture.

Chashnik also sought to extend Malevich's Suprematist theories. His solutions are later than those of Lissitzky, but they similarly attempt an illusion of three dimensions. The sophisticated balance of Chashnik's style, symmetric in effect, approaches art deco. The construction in the Thyssen-Bornemisza Collection, however, is uncharacteristically rigorous. It repeats the composition of a 1925 drawing, possibly a study for a poster. Its relief elements are elegantly posed, and in his choice of colors Chashnik challenges Malevich's more austere placements of the same black, white, and red.

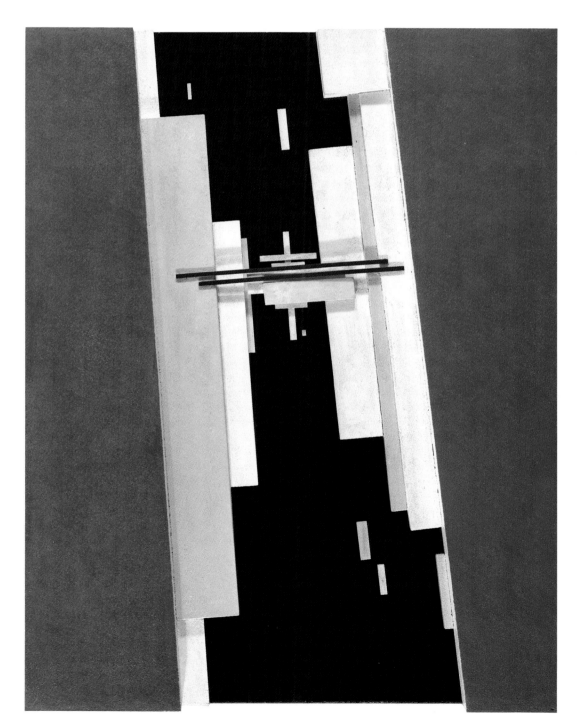

23
Kurt Schwitters (1887–1948)
Picture to Be Seen from 8 Sides 1930
Oil on canvas
35⅞ × 35½ in. (91 × 90cm.)

In the Thyssen-Bornemisza Collection, two later paintings continue Constructivist concepts elsewhere in Europe. Both artists had already developed non-representational styles. Their individual paths toward abstraction, however, evolved quite differently.

After the First World War, Kurt Schwitters was associated with the German-speaking Dadaists, although he never adopted the revolutionary political views that they sometimes espoused. In 1918, in his native Hanover, Schwitters launched a one-man Dada blitz. He wrote poetry and prose. He was as well a painter, a sculptor, and an architect; and he also became a typographer and a publisher. However, it is his collages that express the quintessence of his art. They salvage rubbish: bits of wood, wire, and wheels and, particularly, the printed jetsam of urban life. Schwitters selected and combined these ingredients into assemblages — he called them "Merz" pictures — and his transformations have become precious icons of our time.

Early in the 1920s, Schwitters's studio in Hanover attracted several artists who came to Germany: El Lissitzky, the Russian Constructivist; Theo van Doesburg, the propagandist of the related Dutch movement *De Stijl* ("the style"); and the younger Hungarian artist Lazlo Moholy-Nagy. Schwitters was closest to Lissitzky, and both profited from their theoretical discussions. Schwitters in no way abandoned his Merz collages, but in a few paintings he replaced waste materials with larger geometric forms, exact in contour, flat in shape, and single in color.

The format of the Schwitters picture is square. A wide right angle dominates the composition, and it contains and overlaps a variety of less rigid geometric shapes. Beyond this corner, the two independent elements that float freely, the black plane and the red circle, recall the visual vocabulary of Malevich, Lissitzky's mentor. As the title of the Schwitters painting suggests, the composition may be viewed from any side and from any angle.

24
Piet Mondrian (1872–1944)
Composition in Red and Blue 1931
Oil on canvas
19⅝ × 19⅝ in. (50 × 50cm.)

Piet Mondrian was never comfortable with the human figure, and, in retrospect, his early allegories can be studied only with embarrassment. His interpretations of the Dutch landscape and his precise renditions of single flowers, however, reveal an extreme sensibility and they are less weighted by Symbolist content.

Later, in Paris, Mondrian absorbed the Cubist experience and adopted its essentially monochromatic palette. When he returned to the Netherlands in 1912, the focus of his vision had completely changed. Waves and stars, the pier and the ocean, suggested aerial perspectives that he distilled into gridded notations of short horizontal and vertical lines. He also studied the facades of buildings and reduced their architecture to boxed rectangular patterns. In addition, Mondrian must have reexamined the paintings of Pieter Saenredam whose interiors of Dutch churches in the 17th century often depicted flat, geometric pavings.

Mondrian's return to the Netherlands coincided with the development of *De Stijl*, a movement initiated by other Dutch artists during the First World War. *De Stijl*, a unifying concept embracing all the arts, reduced the elements of composition to rectangular forms independently articulated, asymmetrically placed, and painted in flat, usually primary colors. Mondrian contributed greatly to the concepts of *De Stijl*, indeed he was its most important painter. However, he was a very private and independent person. He returned to Paris during the first year of peace and resigned from the group in 1920.

Mondrian remained in Paris until the next World War. By reduction and refinement he achieved in his painting an ideal perfection based on his belief in the relationship between the horizontal and the vertical as the principle underlying all creation, in art as well as in nature. His painting in the Thyssen-Bornemisza Collection, also horizontal in format, is a superb example of his classic style. On the pure field of white, five straight black stripes meet to form seven smaller rectangles, two of which contain different primary colors. The composition is flat, but its balance is neither static nor symmetric. The geometric purity of its organization is monumental, deceptive in its simplicity and sublime in its clarity.

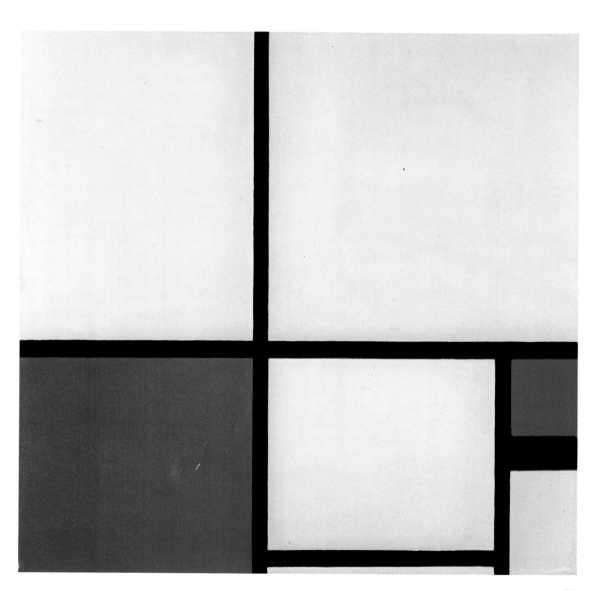

25
Juan Gris (1887–1927)
The Smoker 1913
Oil on canvas
28¾ × 21¼ in. (73 × 54cm.)

Analytical Cubism, as yet significantly unrepresented in the Thyssen-Bornemisza Collection, was in no sense a movement. It was a stylistic marriage between two painters and it concerned only them. The immediate followers of Picasso and Braque were Juan Gris and Fernand Léger, and before the First World War dispersed them, these four constituted the essential core of Cubist painters.

In 1911 in Paris, Gris met his fellow countryman Picasso, and quickly understood and absorbed the new pictorial language that he and Braque had developed. Gris was the most representational of the Cubist painters, and he was also the most lucid. When he died, at the age of forty, he had remained more faithful to Cubist theory than either Picasso or Braque. Gris was primarily a master of still-life, and his Cubist paintings of figures can be discounted on the fingers of one hand. Two, *The Smoker* and *Man in a Café* at the Philadelphia Museum of Art, are troubled by an effect of whimsy that probably was unintentional. In both paintings Gris sets a figure in motion by observing multiple views of the subject.

The man in a top hat, perhaps Frank Burty Haviland, ticks like a metronome to Futurist time. The rendering of the head is unclear, and essentially frontal images conceal a profile of the face. The dislocations of eye, ear, and nose seem superfluous and, like the cleft chin, they uncomfortably approach caricature. The outlines and the volumes of the top hat fan across the upper half of the composition. These strong rhythms sit heavily on the horizontal accents of the man's shoulders. The absurd string tie *is* amusing, as is the conceit of the blue tipped cigar with its spiral of smoke that changes color as it rises.

The subject matter of the Cubist paintings of Braque and Picasso was static, and it remained limited to their studios. Léger, and occasionally Gris, stepped into the world outside. That world was the city and Léger celebrated its architecture and dynamism. For him, as for so many artists of the 20th century, the city and the machine represented energy and movement, and both became symbols as well as symptoms of the industrial age. In the same year that he painted *The Staircase*, Léger said:
"The condensation of the modern picture, its diversity, its dislocated forms — all result from the tempo of modern life."

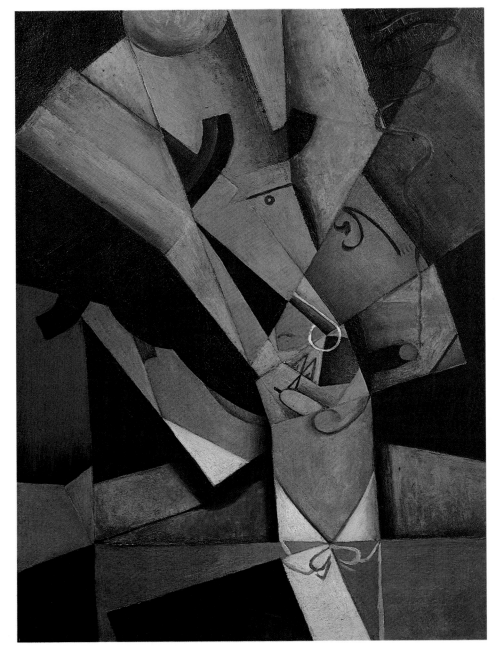

The theme of figures on stairs and on scaffolding is constant in Léger's art, and it has been suggested that he was initially influenced by Marcel Duchamp's stroboscopic *Nude Descending a Staircase*, painted in 1911. Stairs, of course, imply movement. Here in Léger's composition geometricized and somewhat disjointed automatons clink up and toward the spectator. Instead of the flat, transparent, and fractured planes of Cubism, Léger structures a vocabulary based on volumetric cylinders and cones, each of which seems pivoted into place. Léger uses unbroken black lines to describe contour, and with one slight exception, color is limited to primary red, yellow, and blue encased in areas that they do not always fill. Léger's view is cinematographic, a close-up that focuses on moving figures crowded into a passage that is relatively small.

Léger's staircase appears to be an exterior appendage to an undefined building. At the extreme left, a facade of houses runs parallel to the stairway's banister. Above, and moving down from top to right, the flat rectangular forms painted yellow are perhaps the paddles of a ferris wheel which, in Paris at that time, was situated adjacent to the Eiffel Tower. Only the movement of Léger's segmented, quasi-mechanical forms suggests the actual stairs on which they tread. Among the blue figures, anonymous and completely devoid of any sensual appeal, the central robot with its ovoid head seems the most individual. "As long as the human body is treated as a sentimental or expressive value," Léger wrote, "no new development in figurative painting remains possible."

26
Fernand Léger (1881–1955)
The Staircase 1914
Oil on canvas
34⅝ × 49in. (88 × 124.5cm.)

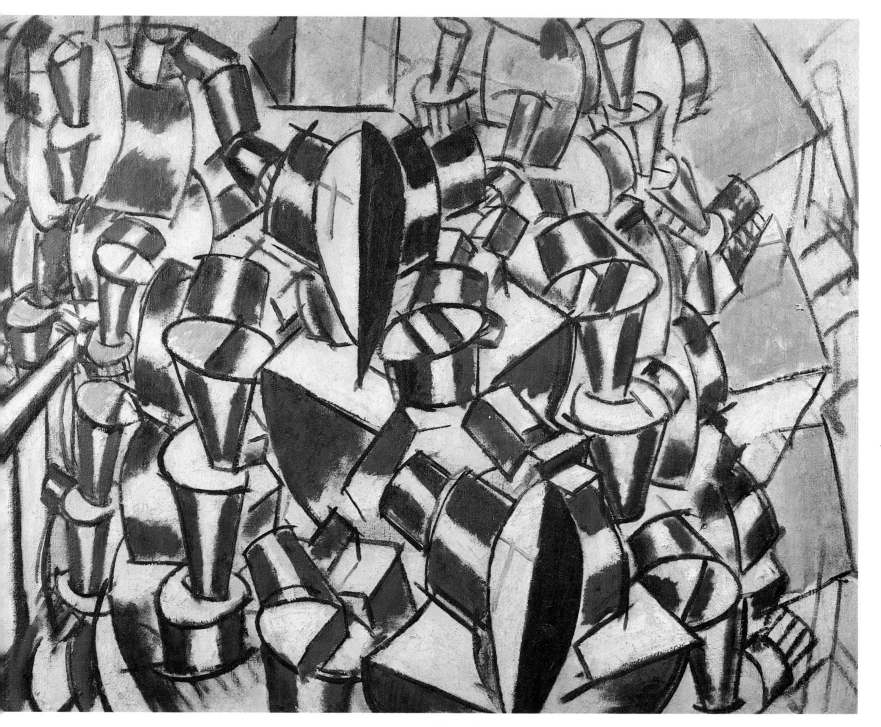

Max Weber (1881–1961)
New York 1913
Oil on canvas
40 × 32in. (101.6 × 81.3cm.)

Both paintings on these pages offer opposite reactions to the hectic rhythms of urban life that certainly did not exist before the 20th century.

Max Weber, the American painter, returned to New York from Europe in 1909. In Paris he had become friends with Henri Rousseau, met Picasso and had studied briefly with Matisse. Weber, as yet, was unable to coalesce a single artistic identity, but he was eager and precocious, and his eyes were alert to the new. In France, he had quickly assimilated *Fauve* and Cubist influences, but in New York he developed these styles on parallel, as well as alternate routes. In addition, Futurist gesture and Expressionist exaggeration contributed to the development of his style.

In 1910 Weber met the American photographer Alfred Stieglitz, at whose small gallery at 291 Fifth Avenue he arranged Rousseau's modest, but nevertheless, first one-man exhibition in the United States. Rousseau had died that same year. Unfortunately, Weber's relationship with Stieglitz, the not-quite-Yankee entrepreneur of the new, was not happy. Of the two, Weber was more familiar with the innovations of the Parisian avant-garde, but Stieglitz had the facilities and the pedagogical inclination to explain them.

Stieglitz's "291" studio and exhibition gallery in New York confirmed much of what Weber had already admired in Paris, the camaraderie of fellow artists and the excitement of new ideas. It also offered a new and particularly American stimulus — the apotheosis of skyscrapers and the recent architecture of downtown New York as photographed, drawn and painted by Stieglitz and his friends.

Within the ambiance of "291," Weber considered himself, perhaps correctly, more pictorially advanced than any of Stieglitz's other associates. The year of Weber's kaleidoscopic view, 1913, was also the year of the Armory Show in New York. Weber refused to participate; that same year he also quit Stieglitz and "291."

Weber's spinning aerial view is specifically Manhattan. Tall, flat-topped buildings with stenographically incised fenestrations rise like stockbrokers' ticker tapes. In Weber's painting, the proliferation of such architecture is prophetic rather than exact. At the top stretch the cables of the Brooklyn Bridge. Also seen are coiled elevated tracks, and a glimpse of Battery Park. Devoid of people, Weber's painting celebrates the urban age.

Like Max Weber, George Grosz also commemorates a capital city. Grosz's synopsis, however, is no euphoric celebration, and his metropolis is damned. The occasion is catastrophic, and day has become night. An urban inferno, crushed by high-rise architecture, is fevered by frantic human movement. The overall tonality of the painting suggests conflagration, and the desperate pedestrian tumult seeks exodus from an unseen, imminent, and overwhelming disaster. Grosz's city is Berlin.

Grosz moved to Berlin in 1912, and during an unexpected respite from military service in the First World War he was allowed to return for eight months, from December 1916 through August 1917. During this leave, Grosz painted three kaleidoscopic views of his adopted city. "Great cities," he later wrote, "had always fascinated me. I had felt the spell of huge towers with their myriads of human ants and termites, each engrossed in a tiny world of his own. I had felt the hidden joys and terrors and fears of urban life. I had been powerfully stirred by the great human drama which is a composite of these joys and sorrows."

Berlin, newly powerful and rich, was a center of government and finance, as well as a megalopolitan nexus of artistic life and iconoclastic attitudes. Grosz, always a moralist, clinically examined the people of the streets and the denizens of its orifices. His dream of a great city, however, was not the Prussian capital. In the New World, in New York and Chicago, he believed he would discover the ultimate urban utopia. At the top left of the Thyssen-Bornemisza painting, the American flag is already unfurled.

In the foreground of Grosz's *Metropolis*, the movement of figures is lateral, primarily from right to left. In the center and at the corner of two diagonally converging sheets, looms a large edifice with an onion-like dome, the Hotel Atlantique. The building's prow confirms the vertical accent of the street lamp but neither in any way halts the human frenzy. At the left, strangely illuminated, and on a smaller scale, the hotel reappears and blocks any exodus. Through the crowd lurch macabre phantoms and disfigured faces, all adding to the convulsive terror of Grosz's apocalyptic nightmare. The kinetic scene is probably the one admired by Walter Mehring, who met Grosz in 1916 and visited his studio. Later, Mehring remembered the painting's title as *Reminiscences of the Entrance to Manhattan*. The composition relates to earlier sketches by Grosz in pen and ink. Of these, the closest to the painting, a drawing of 1915, offers an imaginary view of New York. The sun and high buildings are the same, and the drawing's dense network of lines and letters extends as well to a Chicago Beach hotel, a Denver Express, an elevated tramway, and an American Indian and the American flag.

In 1932, at the age of forty and as a refugee from Nazi Germany, Grosz arrived in America to begin a new life.

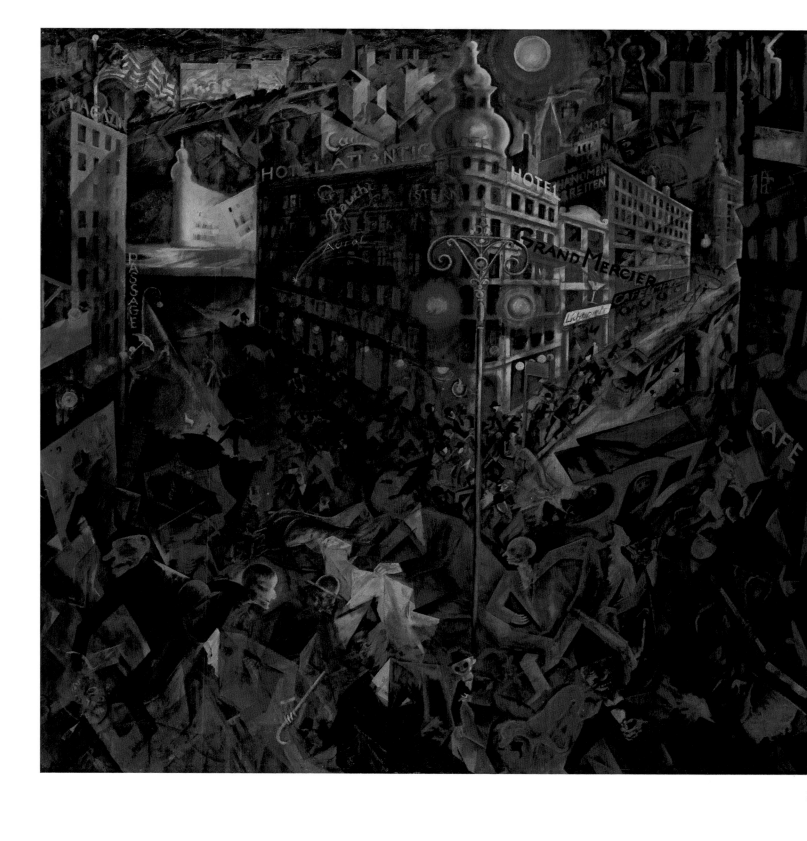

Lyonel Feininger (1871–1956)
The Man from Potin 1921
Oil on canvas
39⅜ × 31in. (100.3 × 78.7cm.)

In 1919 the American painter Lyonel Feininger was the first artist recruited by the German architect Walter Gropius for his faculty at the Bauhaus School in Weimar. Among other prominent artists soon summoned to the school were Kandinsky, Klee, Schlemmer, and, later, Moholy-Nagy. These teachers shared no common ideology, and each believed in an individual pictorial vocabulary. With an inspired director and dedicated students, the teachers of the Bauhaus attempted, and achieved, an integration of the visual arts, craft and the machine. This juncture became the focal synthesis and the working environment of the school. During the early decades of the 20th century, such a dream was frequent,

but only at the Bauhaus was it realized successfully, and in one circumscribed location. For Feininger, the Bauhaus represented an ethical approach to art, a community of friendship and exchange, and an intellectual nutrient necessary to everyday life.

Feininger remained with the Bauhaus until it closed in Dessau in 1932. One day at the end of the summer of 1922 he wrote his wife Julia: "An endless series of pictures develops in my fantasy. I long to realize these visions. There is Paris: the typical Parisian figures; the old architecture and the streets with colorful, bustling people; the Luxembourg Gardens where we pushed Andreas [the eldest of their three sons] in his pram; the Boulevard Montparnasse where we bought *petites suisses* for our suppers at home in our *petit chalet*. The more I advance as a painter, the deeper grows my love for those memories. They are experiences that are inseparable from our life together."

In his letter to Julia, Feininger specifically recalled the years 1906-08. His journalistic success as an illustrator in Germany and as a cartoonist for the *Chicago Tribune* (he had not yet seen Chicago) had allowed him to finance his promise to spend their delayed honeymoon in France. In Paris he and Julia set up their first home in an apartment on the Boulevard Raspail. They remained for two years, and during this time he altered the direction of his art and began to paint in oil on canvas. By coincidence and after they had left, Picasso took a studio in the same building. In 1911 Feininger returned to Paris. The city, he wrote Julia, was "agog with Cubism," and the way that he looked at its architecture radically changed. *The Man from Potin* and the *Lady in Mauve*, however, are recollections of his earlier sojourn.

Feininger was a prolific draftsman. He always carried in his pocket small sketch pads, and he filled their pages with innumerable quick impressions of what he wished to remember. At his death, two trunkfuls of these notebooks recorded penciled observations of some sixty years. In 1906 and 1907 in Paris he admired the narrow streets, the high houses, "the tall chimneys that grew like flowers in pots," as well as the busy pedestrians in the city's older quarters. Such notes are the nostalgic basis for both later

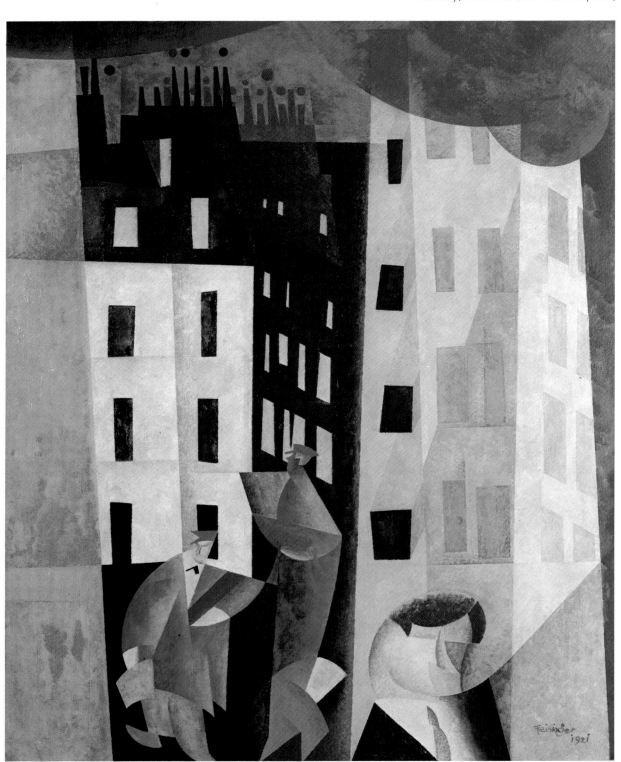

paintings in the Thyssen-Bornemisza Collection. About the same time Atget, the photographer, was also recording the rapidly vanishing architecture of old Paris, and from his prints we know that many of the buildings that he and Feininger saw were already condemned and scheduled for demolition.

On its reverse, *The Man from Potin* is also titled *Architecture II* placing it between an *Architecture I*, a painting neither located nor recorded, and *Architecture II* of 1927, a horizontal view of a row of gabled houses that has nothing to do with Paris. Feininger often painted sequentially, but the interrelationship of the three paintings cannot be established, if indeed it ever existed. "Potin," as a word in French, suggests gossip or a grocer, but here, Julia Feininger explained, it refers to a place. She has also pointed out that the features of "the man from Potin," the cropped figure at the right, resembled those of Feininger himself. The two additional men who contribute to the narrative are repeated from earlier paintings and drawings. One reads a newspaper, the other vends them.
The suggestion of a view from a curtained window looking down is unique in Feininger's art.

In format and size, the *Lady in Mauve* is an exact companion to *The Man from Potin*. Together they handsomely illustrate Feininger's personal style which absorbed the planar analysis of Cubism and added to its overlapping transparencies the lateral rhythms of Futurism. Paris, of course, is a city of night as well as day, and nighttime and daylight simultaneously exist in both paintings. The composition of each, in addition, suggests a stage with a painted backdrop against which figures parade.

In 1906 Feininger developed a penciled notation of a streetwalker into a finished drawing in pen and black ink. The small sheet must contain at least 200 lines, and Feininger titled it *La Belle*. The drawing, retitled *L'Impatiente* by an editor, was published in the French magazine *Le Temoin* the following year. The drawing, also collected by the Baron Thyssen-Bornemisza, elucidates the later painting. "La Belle" walks away from the spectator but glances back. Her left hand coyly raises her skirt, and her right hand rests on a furled umbrella — in the painting, a promenade stick. The painting generalizes the architecture and geometrizes its planes, and the buildings seem to advance as well as recede. The cobblestones of the drawing disappear, and the foreground becomes a flat stage. The raised hem and the glimpse of a laced petticoat beneath it are transformed into an arc emphasizing the movement of feet, a pictorial device that Feininger also exploits in the central figure in *The Man from Potin*.

In 1936, after an absence of half a century, Feininger left Germany and returned to the United States. Twenty years later he died in New York, the city where he was born.

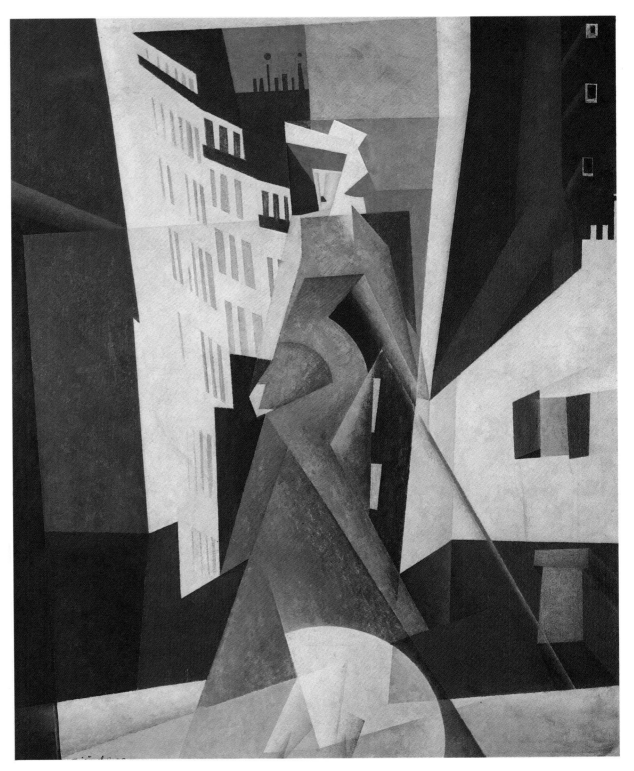

31
Fernand Léger (1881–1955)
The Bridge 1923
Oil on canvas
36¼ × 23⅝in. (92 × 60cm.)

The decade of the 1920s popularized the machine and it invented the word "robot." In painting, photography, and literature, the machine assumed significance as subject matter, and it was deified, humanized, and occasionally condemned.

Le Corbusier, the chief theorist and pioneer of 20th century design, declared that "the house is a machine in which to live" and that machine aesthetic emphasized function and structural honesty. The logic and theory of proportion that accompanied technological advances were also reflected in painting and sculpture. Le Corbusier, the architect, was also a painter.

Through the early 1930s the term *style moderne* embraced several concurrent trends, and it was applied to all the visual arts. At the time, *style moderne* offered a convenient umbrella that could extend from Art Deco in France and the Radio City Music Hall in New York to the Bauhaus in Germany and *De Stijl* in Holland. Any definition of the term is therefore imprecise, and it was not confined to architecture. These paintings by Léger and Kupka illustrate two of its various attitudes. Within twenty years, the usage of the term, originally an approbation of modernity, became deprecatory.

Style moderne, at its best, associated pictorial clarity with geometry and the machine. It sometimes allowed embellishment and handicraft, and it exploited new materials, for instance plastics, and even exotic textures, for instance snakeskin. At its worst, *style moderne* divorced form from purpose to indulge in frippery or extravaganza.

In sculpture, surfaces were sleek, carved from wood and stone, cut from plastic, or cast in metal. Similar smooth casings appear in paintings both representational and abstract. The 1920s, it should be remembered, was also the decade that introduced chrome-plated steel and tubular furniture. Brancusi had said, "High polish is a necessity that certain approximately absolute forms demand of some materials."

Some artists chose to explore, and even rectify, the later decorative implications of Cubism. Among them were Ozenfant and Le Corbusier who collaborated to establish Purism, a short-lived artistic movement in Paris. The lucidity of their softly colored paintings, particularly their still-lifes, simplified and flattened Cubism, and understandably, it also owed much to architecture. Léger, the least didactic of Purism's adherents, was its master.

During the 1920s, his painting balanced between severity and decoration. And, throughout his long career, he exploited the directness and heraldic effects of Purism. In his *Bridge*, one of two versions of the subject, only one vertical section of the horizontal span is seen. The composition is strictly frontal, and without indicating their specific use, Léger incorporates architectural and mechanical elements as ornament. The dominant components consist of round or rectangular flat shapes firmly outlined and painted in pure colors that advance and retreat. The three ribbons of undulating hills that relieve the geometric severity of the composition also provide a middle ground that unites the spatial relocations at top and bottom. Unlike most of Léger's urban and "animated" landscapes of the early 1920s, the format of *The Bridge* is vertical.

Kupka's machine was probably painted later in the 1920s, and several similar versions exist. Many sculptors and painters, notably Epstein, Picabia, and Léger, had previously translated into abstraction, movements characteristic of machines. Kupka's interpretation is later and more complex, and, curiously, it seems more dated. The stroboscopic and disjointed rhythms produce a visual cacophony quite different from the sonorous chords of his earlier painting in the Thyssen-Bornemisza Collection (no. 13). The Futurists, a decade before, might have understood best Kupka's clanking mechanical device.

Kupka was deeply impressed by the International Exposition of Modern Decorative and Industrial Arts held in Paris in 1925, and the impact of that exhibition seems to have altered his pictorial vocabulary. In *The Machine Drill*, the rotating wheels and the cranking wrenches celebrate, of course, the power of an industrial age; and Kupka certainly conceived this gleaming machine as an icon of progress, efficiency, and speed. The contraption, however, seems unnecessarily complicated, and the drill itself is almost obscured by the mechanical paraphernalia above it. The tool, polished and realistically painted, sputters with sparks at the bottom of the picture.

The Paris exhibition of 1925 featured the machine as well as Art Deco and other modernistic styles. The exhibition was influential, and it also brought to the attention of a wide audience the architecture of Le Corbusier and the painting of Léger. Le Corbusier's *Pavillion de l'Esprit Nouveau* with its murals by Léger apotheosized the *style moderne*.

32
Frantisek Kupka (1871–1957)
The Machine Drill 1925
Oil on canvas
28¾ × 33⅜ in. (73 × 85cm.)

33
Stuart Davis (1894–1964)
Sweet Caporal 1922
Oil and watercolor on canvas
20 × 18½ in. (51 × 47 cm.)

In their Cubist paintings and collages Braque and Picasso had used letters as objects, as autonomous pictorial elements, suggesting incidentally, if at all, words and names. In the two paintings reproduced here, the combination of letter image is more illustrative, and the correspondence is literary as well as pictorial. Content is as significant as form, and a recognition of the meaning of the words portrayed is necessary to an understanding of what each artist paints. Stuart Davis's picture is a still-life, Charles Demuth's a portrait.

When Davis died, he had been an unacknowledged leader of the American avant-garde for more than forty years. His achievement was great, his paintings snap with vitality, and only an American artist could have painted them. As a young artist in 1913, Davis had been deeply impressed by the feast of modern European art presented by New York's Armory Show. (He himself was perhaps the youngest of its American contributors, and he showed five watercolors illustrating honky-tonk night life in Newark.) To Davis, the patterns and colors of Gauguin and Matisse seemed incredibly direct and bold, and he also studied the more formal disciplines of Cézanne and Seurat. What he admired most, however, was more recent, and to him, completely innovative: the analytic observation of the Cubist painters, particularly as revealed in their still-lifes. Inspired by Cubist examples, Davis himself invented a few collages, but during the early 1920s, he abandoned these brief experiments with paste and paper, and painted a series of still-lifes that simulate collage. These pictures can also be related to an earlier and American tradition of *trompe l'oeil*. They juxtapose lettered word and painted image, and among these "imitation collages," two incorporate brand names of smoking tobacco, *Lucky Strike* (1921) in the collection of the Museum of Modern Art, and the smaller painting, *Sweet Caporal* owned by the Baron Thyssen-Bornemisza.

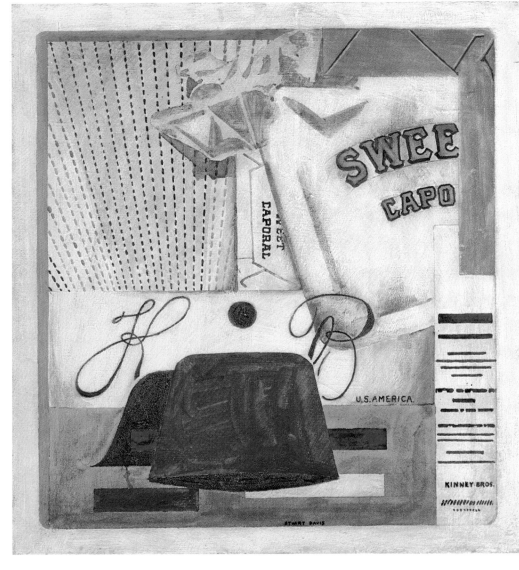

One or two summers after the Armory Show, Charles Demuth met Davis in Provincetown. Demuth encouraged the younger painter with his own first-hand experience of the Parisian avant-garde. He himself would join the circle of artists clustered around Alfred Stieglitz, a coterie that never appealed to Davis.

Demuth's *Homage to Gertrude Stein* is one of the last of his "poster portraits" begun in 1924. The most famous in the series is "*I dreamt I saw the figure 5 in gold*," an homage to his friend the American poet William Carlos Williams, in the collection of The Metropolitan Museum of Art. The Thyssen-Bornemisza painting is of course a tribute to Gertrude Stein, whose acquaintance Demuth had made in Paris before the First World War. Other "poster portraits" include as their subjects painters associated with Stieglitz, the playwright Eugene O'Neill, and Bert Savoy, a female impersonator.

In his series of poster portraits, Demuth was probably inspired by two literary sources: Walter Pater's characterizations of cultured men who might have existed in the past, and Gertrude Stein's word portraits of friends who she admired or chose to favor. Demuth in addition knew Marius de Zayas's "geometric equivalents," abstract portraits in charcoal drawn a decade before. De Zayas was a Mexican artist who contributed considerably to the pictorial taste of Stieglitz. He, as well as Marsden Hartley and Francis Picabia, two other artists associated with Stieglitz, had incorporated letters, numbers and words in portraits of their friends.

Homage to Gertrude Stein can be considered a flag as well as a poster. The centrally placed mask of shiny satin, somehow not quite appropriate to Miss Stein herself, floats above the juncture of three flat geometric fields. Repetitions of sequences of three are frequent in Stein's early writings, thus in Demuth's portrait the numbers one, two, three, and thrice the word "love." What Miss Stein thought of her symbolic likeness she did not say. The painting, however, made a deep impression on Robert Indiana, the American artist, who was born in the year the portrait was painted.

Homage to Gertrude Stein was formerly owned by Edith Gregor Halpert, who established the Downtown Gallery in New York, and who for more than thirty years devoted unrelenting energies to exhibiting and selling American art. Max Weber's *New York* (no. 27) and Stuart Davis's later painting (no. 61) were also in her personal collection.

34
Charles Demuth (1883–1935)
Homage to Gertrude Stein 1928
Oil on canvas
20 × 20¾ in. (51 × 53cm.)

35
Juan Gris (1887–1927)
Table before a Window 1921
Oil on canvas
39 × 25½ in. (100 × 65cm.)

In France during the five years preceding the First World War, Braque and Picasso established the Cubist tradition of still-life. They were soon joined by Juan Gris, and today that tradition seems classic. The two still-lifes here were painted later, in 1921 and 1938. In both, Cubist analysis surrenders to decorative effect. Shape is suggested by line, and form is not tangibly defined. Foreground and background become a single cohesive scheme, and both painters impose a visual discipline that does not attempt to present viable space. Who could move behind either table? Who could hold any object in the still-life arrangements? Instead, the intent of both painters is to structure a lively all-over pattern the organization of which subsumes all or any of its contributory elements. Cubist austerity may be lacking, but the result is glorious, and the method is much more considered than it seems.

The table tops tilt abruptly, and a graceful cursive idiom unifies the description of the still-life arrangements. Color is factual only when it serves rhythmic ornamentation. What remains faithful to classic Cubist tradition is subject matter, and the domestic paraphernalia of the artists' ateliers is familiar: household china, glassware, fruit, a book, and a musical instrument. Only a playing card (the ace of clubs) is missing. What differs from classic Cubist tradition is the definition of the table as furniture, the tablecloth's important role as a compositional component, and the architectural setting of the surrounding room.

Gris, unlike Braque or Picasso, frequently included a window in his paintings of objects in his studio. In the Thyssen-Bornemisza still-life we see a table and, crowded upon its cloth, a guitar, a book, and a compotier with a bunch of grapes. Below is a carpet, and beyond, an exterior view of two buildings. The scene, facile to describe, cannot be easily plotted in pictorial space. Gris does not care that the diagonal rectangle of the small rug forms a block at the left, or that the rug crosses under the table and, at the same time, above the guitar. He molds the tablecloth to fit the contour of the guitar, and he also raises the cloth to form an angle that is not, in fact, a third peaked building outside. His interest, of course, is pattern. Even color assumes a role independent from the object, for instance the two contrasting pages of the opened book. Repetition of lines and forms creates descending and ascending rhythms: the six strings of the guitar interrupted by their counterpart on its neck; the six lines of text on both pages of the book; the six folds of the cloth; or, mounting, the curves formed by the edge of the table and the lip of the bowl; the angle of the fruit's stem and the two roofs; and the single straight line that arbitrarily divides the sky. The pair of curtains implies symmetry, but they are dissimilar in size, and that difference helps to set the composition into motion.

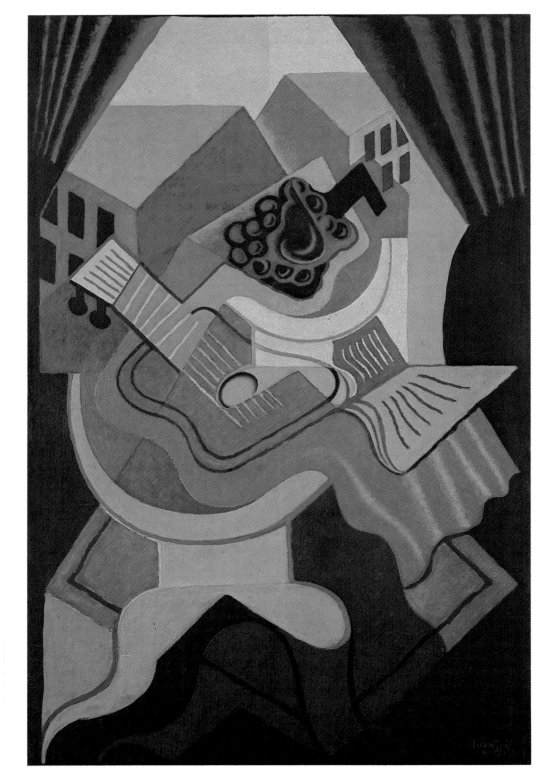

Braque's similarly frontal arrangement is more static, at least in his still-life in the Thyssen-Bornemisza Collection. The painting, within Braque's career, follows a series of tall *guéridons*, necessarily vertical in format, that he had begun in 1918. It corresponds more closely, however, to an alternate series of still-lifes, frequently horizontal in format, that Braque painted through the 1930s. This second series shows objects placed on mantelpieces of lower tables. In 1949 Braque began his final sequence of still-lifes, some of which were simultaneously painted. These late pictures do not focus on arrangements on a single table. Instead, they offer a wide view of the interior of his studio. They encompass several pieces of furniture and a variety of objects placed at different heights. In addition, these views also incorporate into their composition other paintings that he kept in his studio to study or to finish.

The different motifs of *The Pink Tablecloth* are marvelously organized; and form, line, and color have separate functions. The scalloped cloth crosses the picture's plane and lies flat against the zig-zag patterned wallpaper. The subordinate straight lines in the wall moldings and the glimpse of table stabilize the contrast of undulations and angles. The grey and pink of the still-life decoratively complement the stronger colors on the wall that, in turn, form their own independent design. The texture of the paint is granular, and several lines are actually incised into its surface.

36
Georges Braque (1882–1963)
The Pink Tablecloth 1938
Oil and sand on canvas
34⅜ × 41¾ in. (87.5 × 106cm.)

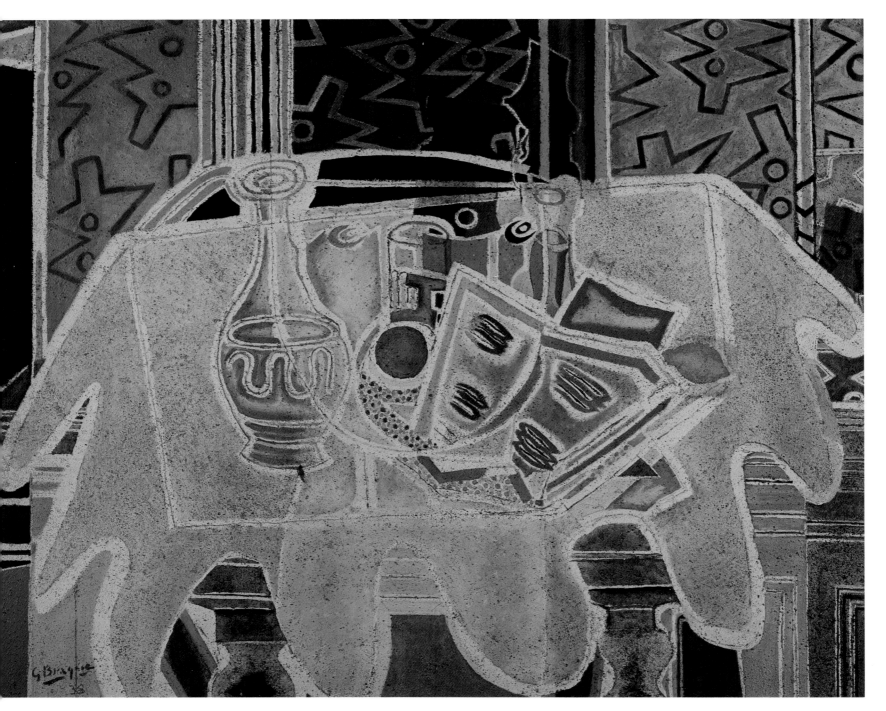

37
Marc Chagall (born 1887)
The Rooster 1929
Oil on canvas
31 ⅞ × 25 ¾ in. (81 × 65.5cm.)

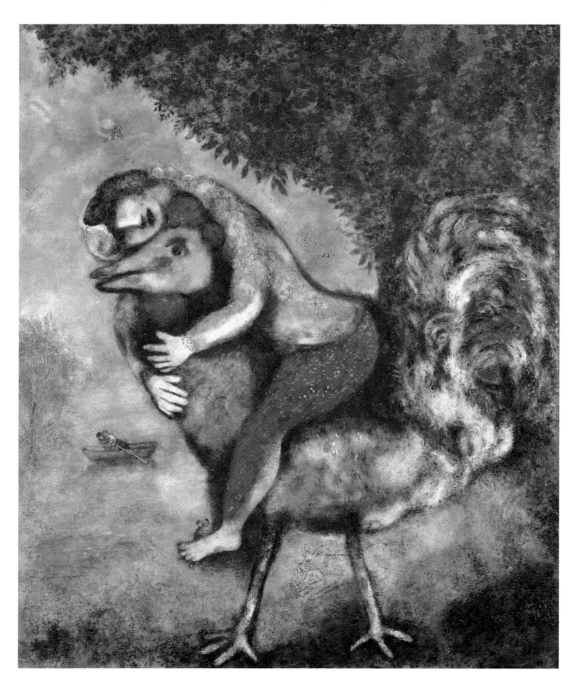

Marc Chagall met Ambroise Vollard, the great French art dealer and the passionate *editeur* of prints and illustrated books, in the winter of 1922–23. Chagall had just returned to Paris where he had stored several canvases with his friend Gustave Coquiot. These paintings had been seen and admired by Vollard who insisted that Coquiot introduce him to the Russian painter. They met, and Vollard immediately commissioned Chagall to illustrate an appropriately Russian theme, Gogol's *Dead Souls*.

Chagall's next commission for Vollard, 100 etchings for La Fontaine's *Fables*, was begun in 1927 and was finished in 1930. The earlier of the Thyssen-Bornemisza paintings relates to these illustrations which were originally conceived in color and not in black on white. The same fantastic bird appears in illustrations of two of La Fontaine's poems, "The Rooster and the Pearl" and "The Rooster and the Fox." Chagall's bird, no pecking farmyard fowl, is a proud mount affectionately held by a young rider. In the distance, in a rowboat floating on a river, a pair of lovers also embrace.

Chagall has depicted episodes from the *Old Testament* in many media but never more eloquently than in his third series of illustrations for Vollard begun in 1931 and finished in 1939. Since that time, Chagall's "message biblique" has increased, and it incorporates two visual focuses of Christian worship, the Virgin and the Child, and Christ's death on the Cross. The Thyssen *Madonna*, one of Chagall's most beautiful, may seem nonorthodox to a Christian, but how very much more unexpected such a subject must seem to a Jew.

At the lower left, the jumble of buildings ramshackled and askew is Chagall's recollection of his birthplace, Vitebsk, and the view of the village is illuminated by a Sabbath candle. At the lower right, "the river of my native town, flows very peacefully." Across the canopy of a yellow cloud, and in refreshing confusion float several figures: a man bearing a bouquet of flowers (Chagall's declaration of love), a cow with its fiddle, a unique interpretation of the Annunciation, and in the sky below, an angel with legs crossed and the archangel Gabriel with his horn. All pay homage to the Madonna who dominates the composition. Her white dress conforms to no Christian iconography, but for Chagall its color symbolizes marriage. She holds the Child, a hefty infant with features of a youthful Chagall, and, quite literally, she is adored by the levitated figure above her.

Both Thyssen paintings celebrate love, and the *Madonna* specifically maternity. At the time the latter was completed in New York, Chagall was the new and proud father of a boy. Perhaps it should also be remembered that upon his arrival in New York in 1941 Chagall visited The Metropolitan Museum of Art where he was tremendously impressed by El Greco whose paintings he was able to study for the first time.

38
Marc Chagall
Madonna of the Village 1938—42
Oil on canvas
40¼ × 38½in. (102.5 × 98cm.)

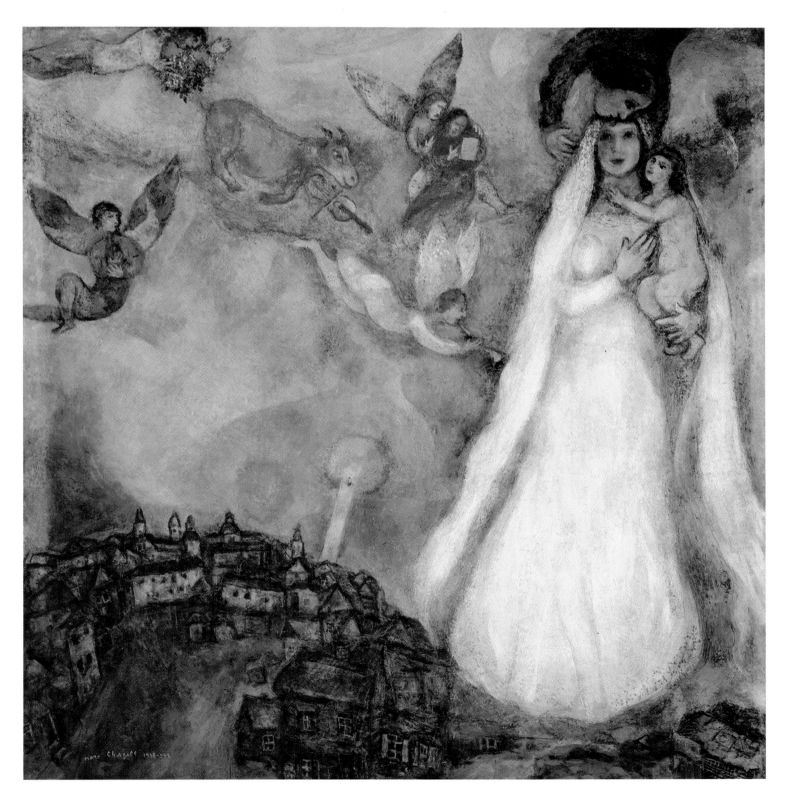

39
Joan Miró (born 1893)
Catalan Peasant with a Guitar 1924
Oil on canvas
57¾ × 44¾ in. (147 × 114cm.)

In 1924 the French poet André Breton announced the advent of Surrealism which he defined as "pure psychic automatism . . . in the absence of all control exercised by reason, and beyond all aesthetic or moral preoccupation

Surrealism rests in the belief in the omnipotence of the dream." Surrealism's visual exploration of the subconscious pursued both paths, automatism as suggested in Miró's painting of a man, and the dream as in Tanguy's "hand-painted photograph."

Joan Miró was born in Barcelona in 1893 and first visited Paris as a young man in 1919. There he developed a tight realistic style, literal in its observation and precise in its description. A sophisticated naiveté graces the stiffness of his figures and adds an engaging exactness to his narrative detail. Miró's early paintings were admired by a small circle of artists and writers in Paris, and both Picasso and Ernest Hemingway acquired examples.

In 1924, Breton "officially" admitted Miró to his Surrealist group. He remained the gentlest of its members. At the time, his paintings expressed, simply and spontaneously, the thematic essence of a single subject. Perspective disappears, space becomes flat. Miró relied on symbol more than fact, but his figures and forms are real, observed or remembered, and their fragments can be easily interpreted.

Miró's painting in the Thyssen-Bornemisza Collection is among his first to float reductive elements onto a thinly painted, uniform field of color, here blue, but elsewhere brown. The man's torso is diminished to one standing line, and a single curve indicates two outstretched arms. He wears a *barettina*, the red woolen cap characteristic of the Catalan peasant that is also a traditional symbol of Catalan independence. His right hand holds a clay pipe — we also see its flame, as well as its smoke — and he carries a yellow guitar. The inverted heart may be variously interpreted, as viscera, genitalia, or feet, all of which embellish similar pictures of the period. Miró's fantasy should be enjoyed with humor, wonder, and delight.

A year after admitting Miró, Breton accepted Yves Tanguy into the Surrealist group. Tanguy's earliest paintings, feisty and figurative, confirm that he was a self-taught artist. However, he soon became adept, indeed marvelously proficient, at painting in oil. Tanguy's first mature paintings isolate biomorphic forms that cast sharp shadows across strange, unfamiliar landscapes, always defined with a horizon.

Subsequently his forms assumed more geomorphic characteristics, and they seem sculpturally conceived. Their worn and polished surfaces invite translation into three dimensions.

In 1939 Tanguy quit France to join Breton and other members of the Surrealist group in New York. He married the American painter Kay Sage, and they lived in Connecticut. Tanguy worked constantly, and in increasing isolation. In his late paintings, the placement of irregular rock-like forms becomes crowded; but the density of their configurations is sometimes relieved by flat, thoroughly unexpected areas of white.

Tanguy pursued Surrealism's alternate path, the painted dream. Light, space, even time function in his landscapes. Life, movement and sound do not. These are desolate graveyards of stone, and their receding vistas conjure up an alien world, barren and disquieting. *Imaginary Numbers*, in the Thyssen-Bornemisza Collection, is probably Tanguy's last painting.

40
Yves Tanguy (1900–55)
Imaginary Numbers 1954
Oil on canvas
39 × 31½ in. (99 × 80cm.)

41
Salvador Dali (born 1904)
Gradiva Rediscovers the Anthropomorphic Ruins 1931
Oil on canvas
25½ × 21¼ in. (65 × 54cm.)

Gradiva, Dali's subject, first appeared as the silent heroine in a novel of the same name by the German writer, Wilhelm Jensen, who was born in 1837. The novel intermingles reality, history and dream. Its plot concerns an archaeologist who purchases a cast of a classical sculpture, the original of which he had seen in Rome. Both plaster and marble, of course, represented the same young, beautiful girl and she was called Gradiva. One night in a dream, the archaeologist finds himself in Pompeii in the year 79 A.D. Vesuvius erupts. In the wake of the disaster, he recognizes the living Gradiva as she advances towards the Temple of Jupiter. She stops to rest. As she sits her head falls, and she is smothered by ashes and suffocated by sulfuric fumes. Once dead, and with her eyes closed, she looks exactly like her image carved in stone. Thus ends the dream. Jensen's story continues in the ruins of modern Pompeii where the archaeologist encounters another young girl. They do not speak, but he knows her name. She resembles the statue that he had purchased, and she sits similarly to the living Gradiva as she, in his dream, died.

In 1907, Sigmund Freud discussed Jensen's story as analogous to the process of psychoanalysis. Freud's essay was read by several of the Surrealists, first by Max Ernst and last by André Masson. Salvador Dali, in 1971, remembered that he called Gala, his own wife, Gradiva, "because she has been the one who advances." And, in 1938 in Paris, André Breton opened a commercial art gallery called Gradiva.

In Dali's painting, a crepuscular haze enhances the mystery of the scene. Two standing figures embrace. They are the dual aspects of Gradiva: the statue, here cracked, and the living woman, veiled and more softly delineated. The pose derives from de Chirico and is often repeated by Dali. The flowing tresses of hair would delight any Symbolist, and they are affected from Leonardo. Without any natural transition, the shadowed foreground melts into the more illuminated landscape, containing ruins and two smaller figures, both fallen and cauled. On the statue's left shoulder rests an inkwell with its pen, perhaps an allusion to Jensen himself. Curiously, in the head and body of the statue, Dali's hallowed form and empty spaces anticipate those of Henry Moore, in his own sculpture, although the work of no two artists could be more dissimilar.

42
Salvador Dali
Dream Caused by the Flight of a Bee around a Pomegranate a Second before Awakening 1944
Oil on canvas
20 × 16 ⅛ in. (51 × 41 cm.)

Dali's later painting lacks the evocative mood of his earlier hallucination. It smacks of Hollywood, and it just misses being a pin-up poster with special effects by Cecil B. de Mille. A reclining nude sleeps suspended above a bed of flat rock that in turn floats upon the sea. In comparison with the cliffs and the beach of sand and steps, this figure seems enormous, wet, and two drops of water congeal beneath her. For some reason, it is quite irritating to observe that her toe nails are varnished.

The plateau, which apparently has been sliced and carved, stretches across the lower third of the composition. At the right and frozen in space are a bee and a pomegranate. The bee is a traditional symbol of the Virgin, the pomegranate a pagan attribute to Proserphina, who each Spring returned to earth, as well as a Christian symbol of fertility and resurrection. The berry casts a heart-shaped shadow. The banality of the tableau vivant is mitigated only by the action above it.

Cast in a different scale and across the expanse of sky, an alarming battery threatens the sleeping nude. From a burst pomegranate, already spilling its seed, springs a giant blowfish that in turn disgorges two raging tigers. Closest to the nude is a bayoneted rifle about to pierce her arm. Perhaps it is best that she does not wake. In the middle ground, near the horizon that divides sea from sky, an elephant mounted by an obelisk stalks across the water on stilted legs. Dali's juxtapositions are widely improbable. However, his irrational images are so photographically conceived and so cleverly manipulated that the lady and her tigers seem real.

In the lower right hand corner, Dali has joined Gala's name to his own signature, his frequent habit.

43
Paul Delvaux (born 1897)
The Grotto 1936
Oil on canvas
28 × 36in. (71 × 91.5cm.)

As did Tanguy and Dali, René Magritte and Paul Delvaux follow de Chirico into an hallucinatory world where anything can happen. Both scenes are concerned with mirrors and windows, both are illogical. Their rendition, however, is so exact that it conspires to lend verisimilitude to what is portrayed.

Delvaux's painting, at first, suggests some classical allegory, and his muse invites comparison with some antique ideal. The face, however, is contemporary, and indeed the medallic profile can be easily identified. Unmoving, the nude stares directly left. The mirror, suspended, but neither held nor attached, reflects a different if similar face seen to us but not by her. This framed image becomes the head of a second figure which is further articulated by the bands of cutwork and reticello lace that serve as limbs. One arm reaches toward the first figure as if about to fondle the bud of an exposed breast. Delvaux clearly recalls the piquant gestures that so intrigued painters of the School of Fontainebleau.

Delvaux's two women are theatrically illuminated, but their habitat is a cave, the dark interior of which is draped with unrealistic formations of rock. The mouth of the cave opens like the flap of a tent to reveal a dry and desolate landscape, a valley of receding boulders stopped by mountains in the far distance. Who are these two companions, and why are they here? Delvaux invites the spectator to write his own scenario.

A suggestion of classical myth may contribute some plausibility to Delvaux's curious pair. Magritte's story, also painted in 1936, is more convincing. What is represented is familiar, therefore its shock is unexpected. The vertical symmetry of the hanging curtains and the horizontal lines of the frame and ledge lend a formal structure to a composition that is suddenly, quite literally, shattered. The window is closed, but shards of glass have crashed and others are about to fall. Through the smashed pane we see the very field, the same paths and the same trees that lie scattered on the floor. A moment of inexplicable destruction is frozen as if captured by the camera.

44
René Magritte (1898–1967)
La Clef des Champs 1936
Oil on canvas
31½ × 23⅝ in. (80 × 60cm.)

45
Max Ernst (1891–1976)
Solitary and Conjugal Trees 1940
Oil on canvas
32 × 39½ in. (81.5 × 100.5cm.)

In 1937, when Max Ernst was not yet fifty, the magazine *Cahiers d'Art* devoted a single, memorable issue to his art. During the next four decades he continued to paint, and his imagination and technical invention never failed. His achievement during these years, however, remains obscured by critical attention that focuses upon his earlier work produced between the two World Wars.

By 1937, Surrealism, to which Ernst's contribution was as significant as that of André Breton, could be considered an historic movement with a beginning and an end. Ernst's major painting of that year, *The Angel of Hearth and Home*, might seem to confirm this. Its ferocious intensity ends an era, its allegory heralds an apocalypse. In succeeding years, Ernst explored a variety of styles. These originated in his innovative methods of applying paint.

In 1939 and 1940, Ernst was twice interned, first by the French as an enemy alien, and then by the Germans as an individual definitely undesirable. During this trauma, he nevertheless managed to develop a method of decalcomania in which he rediscovered for himself the revelatory potential of Leonardo's wall. During the 1920s, it should be remembered, a related method had also contributed to his vision.

What was this decalcomania? Ernst squashed wet pigment between two canvases, pressed them together, and then with a sound that goes pop, rent them apart. The impression left on each canvas was overall. The result looked porous, thirsty like a sponge.

Such surfaces suggested to Ernst definite forms and shapes, and he defined these by painting over the decalcomania or by detailing further its accidental designs.

The flat blue sky of *Solitary and Conjugal Trees* covers the underlying decalcomania. Ernst conjures a landscape, establishes an horizon, and creates a diagonal path. At the right, he plants a progression of impossible trees and lends a shadow to each of their desiccated shapes. At the left, in the foreground, a large area of decalcomania, not untouched, assumes the form of a hill. The vista is joyless. Not even the addition of a tiny moon relieves its barren aspect. A few years later Ernst would see, and admire, the dry clarity of the Arizona landscape.

Less than twenty years separate Ernst's two paintings reproduced here. Between them fall, however, several of his very many lives — among them a third internment (this time in the harbor of New York), two marriages, two citizenships, permanent residence in France, and triumph in his native Germany.

Several of Ernst's late pictures are large,
and they share an underpainting in a dark
color, here purple, elsewhere blue.
This surface is thin, and it serves as a ground
for brighter colors applied with a squeegee,
an artist's tool most often used in the inking
of silk-screen prints.

Ernst's butterflies have chased all but one
young girl from view. A sun explodes,
its fragments of light burst into a kaleidoscopic
bouquet, a gift to his consort, the American
painter Dorothea Tanning.

46
Max Ernst
33 Young Girls Looking for a White Butterfly 1958
Oil on canvas
54 × 42⅛ in. (137 × 107cm.)

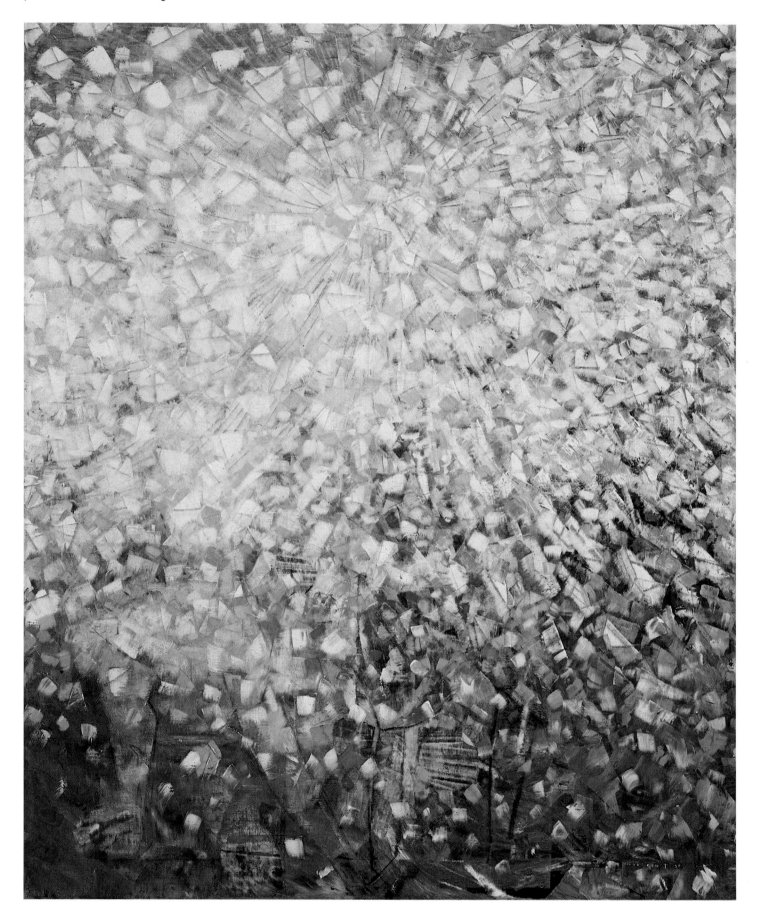

47
Christian Schad (born 1894)
Maria and Annunziata from the Harbor 1923
Oil on canvas
26½ × 21⅞in. (67.5 × 55.5cm.)

In Germany during the 1920s, the consequences of war and defeat accelerated economic disaster, political unrest, and the decline of moral values. New paths were desperately needed, and when they were opened they led to utopia or crisis. Modernism, at least among intellectuals, became established as a philosophy and creed, and at the same time the validity of abstract and other new pictorial vocabularies was challenged.

In Germany, the *Neue Sachlichkeit* (the "New Objectivity" or the "New Realism") was an inevitable reaction to the fever of Expressionism, the anarchy of Dada, and the geometry of the Bauhaus. Some artists called for a new order and that, they believed, was realism. They studied all aspects of their environment, particularly the city and the harsh, as well as bizarre, facts of its life.

They used their eyes as cameras; nothing was added, nothing was omitted. Their gaze was unflinching, and what they painted was precisely rendered. Their focus was sharp, and it paralleled developments of photography in Germany at the same time. An additional term, "magic realism," was invented to describe their exact and convincing images realized in highly finished techniques. The *Neue Sachlichkeit* lasted the life of the Weimar Republic.

The artists of the *Neue Sachlichkeit* excelled in portraiture, and of them, Otto Dix, himself a former Dadaist, is the best known. Recently, however, several "forgotten" artists have emerged from obscurity. The Thyssen-Bornemisza Collection is particularly rich in such examples. Reproduced here are two double portraits of women, both painted in 1923.

Christian Schad was born in Bavaria and studied briefly at the Academy in Munich. He was able to spend the years of the First World War in neutral Switzerland. His early woodcuts are Expressionist in style and theme, and also show the influence of Futurism. In Zurich, Schad became associated with the Dada painters and poets, and he particularly admired the poet Tristan Tzara. In 1918 he produced a series of "schadographs," prints on photographically sensitized paper struck by light without the use of a camera, that anticipate the photograms of Moholy-Nagy in Berlin and those of Man Ray in Paris. A year later, and perhaps inspired by Hans Arp, he constructed a small series of assemblages on wood that in their inventive configurations are extraordinary.

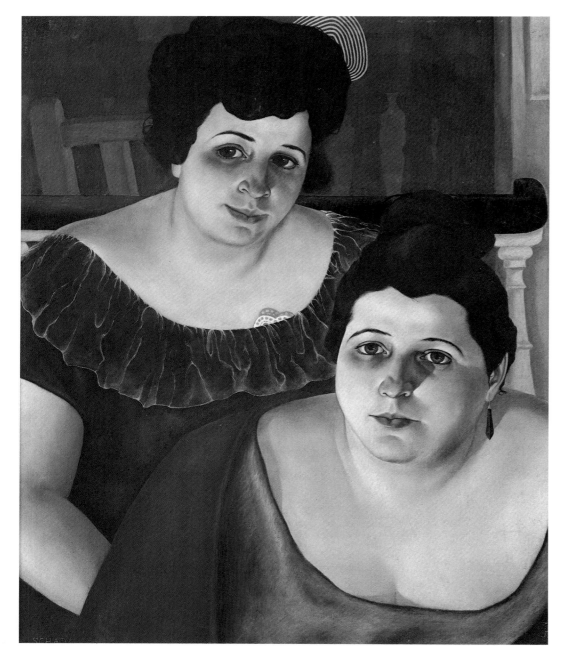

After the war, Schad quit Switzerland. He spent the succeeding years in Rome, Naples, and briefly in Vienna. In 1927 when he returned to Germany, he was an artist of virtuosic accomplishment, and he was quickly identified with the artists of the *Neue Sachlichkeit*. The double portrait here, painted earlier, presents two sisters, both actresses in a troupe that played the Theatro Rossini on the Piazza Dante in Naples. Maria and Annunziata are shown, not on stage, but finely dressed and seated as spectators in a box. The lighting is dramatic.

In Berlin, in the late 1920s, Schad relished and recorded the demimonde, and in a brilliant series of portraits he painted its citizens. Unlike George Grosz, Schad never moralized. His attitude was impartial and completely detached. In 1930 he ceased painting. In 1942 he resumed his career and accepted a commission to paint a copy of Grunewald's *Stuppacher Madonna* in Aschaffenburg.

48
Karl Hubbuch (1891–1980)
Twice Hilde, II 1923
Oil on pasteboard
59 × 30¼ in. (150 × 77 cm.)

Karl Hubbuch taught at the Academy in Karlsruhe, and perhaps not without reason, he remains one of the least known of the *Neue Sachlichkeit* painters. The subject matter of his urban views contrasts the impoverished poor with their capitalist exploiters.

Twice Hilde, a double portrait of the same woman, and its companion painting, are his best, if least characteristic works. Baron Thyssen-Bornemisza owns the left half of a pair of paintings, each the size of a door. The other half is in the collection of the Staatsgemaldesammlungen in Munich. Hung together they would form a composition that is square. In the Thyssen-Bornemisza panel, Hilde appears as she is seen by others. Neither young nor pretty, she is an intellectual. She wears glasses and sits in a new tubular chair designed by Marcel Breuer. Hilde, standing, is dressed for the street. Her disheveled hair is hidden within a toque, and she has rouged her lips. She seems quite graceless. The Munich half of the composition explains her somewhat startled look. This second painting shows two additional and very different aspects of Hilde, one assertive, the other playful. Neither is inviting, and in those poses, Hilde's silk pants stop well above her knee.

49
Edward Hopper (1882–1967)
Girl at a Sewing Machine 1921–2
Oil on canvas
19 × 18⅛in. (48.3 × 46cm.)

Edward Hopper isolated certain but familiar aspects
of the American scene, and he transformed their
commonplaceness. He imbued everyday situations with
quiet drama, and he could induce psychological moods
poignant in their feeling. No other artist has so eloquently
expressed the isolation of the individual in ordinary
surroundings. No other American artist was more a master
of painted light in and out of doors.

Since Hopper's scenes of urban and rural landscape are
almost always horizontal in format, the proportions of both
paintings are unusual. As the styles of the women's coiffures
suggest, a decade separates the two paintings. In the
earlier, in the corner of a larger room, a seamstress bastes
the hem of a piece of cloth. Daylight enters through a
window and casts its light upon the figure sewing and a
geometric pattern upon the wall behind her. The woman's
hair falls loosely and allows only a glimpse of profile.
Figure, chair and sewing machine are seen from the side.
These occupy the foreground and, as a group,
their irregular configuration contrasts with the larger
expanse of the high wall and with the vertical accents of the
tall window. No outside world exists. The woman is alone,
this is where she lives and works.

Its small size relates Hopper's *Girl at a Sewing Machine* to
his watercolors and prints. Indeed, it was painted soon
after a period when Hopper had worked almost exclusively
on paper just before he etched a plate of the same subject.
The later *Hotel Room*, however, is one of his largest
canvases as well as the first, and perhaps the best, in a
sequence of paintings of hotel interiors.

Hopper again observes a single figure alone in the city.
The circumstances, however, are quite different. The time is
night, the temperature is hot. From the left a harsh electric
light, itself unseen, illuminates the narrow space. The woman
has entered her rented room, cast off her shoes,
and placed her hat upon the bureau. Long limbed, she has
undressed to her slip. Her features are cast in shadow as
she reflects upon a letter. The intimacy of her attire and the
weariness of her pose in no way suggest sexuality.
Instead they contrast with the impersonality of the room.
Who is this traveler, and why is she here?

The impact of narrative content recedes as the picture is
studied. Formal, abstract arrangements dominate the
composition. The blue wall, the headboard, the corner,
the window's frame, and the bureau become flat columns
varying in height. These strong verticals contend with the
diagonals of the bed, its sharply defined shadow, the chair,
and the woman's luggage. They also complement several
horizontal accents; for instance, the folds of the curtain
against those of the coverlet. Hopper's juxtaposition of the
night's black sky and the partially drawn shade becomes
geometric, and his placement of the hat is not casual.
These elements are essential to the balance of this
marvelously contained composition.

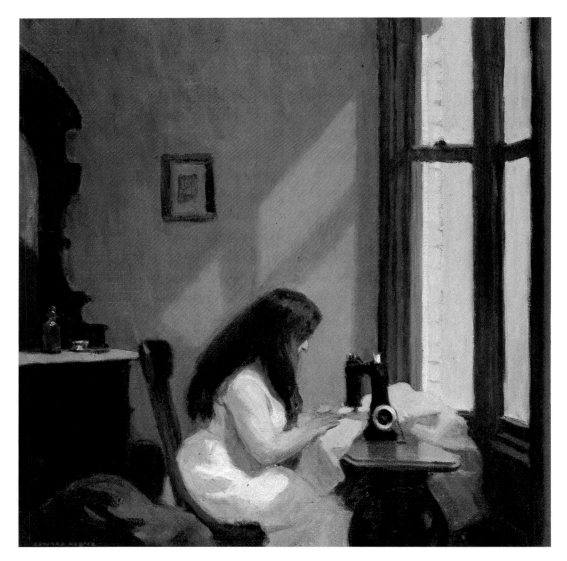

50
Edward Hopper
Hotel Room 1931
Oil on canvas
60 × 65¼ in. (152.4 × 165.7 cm.)

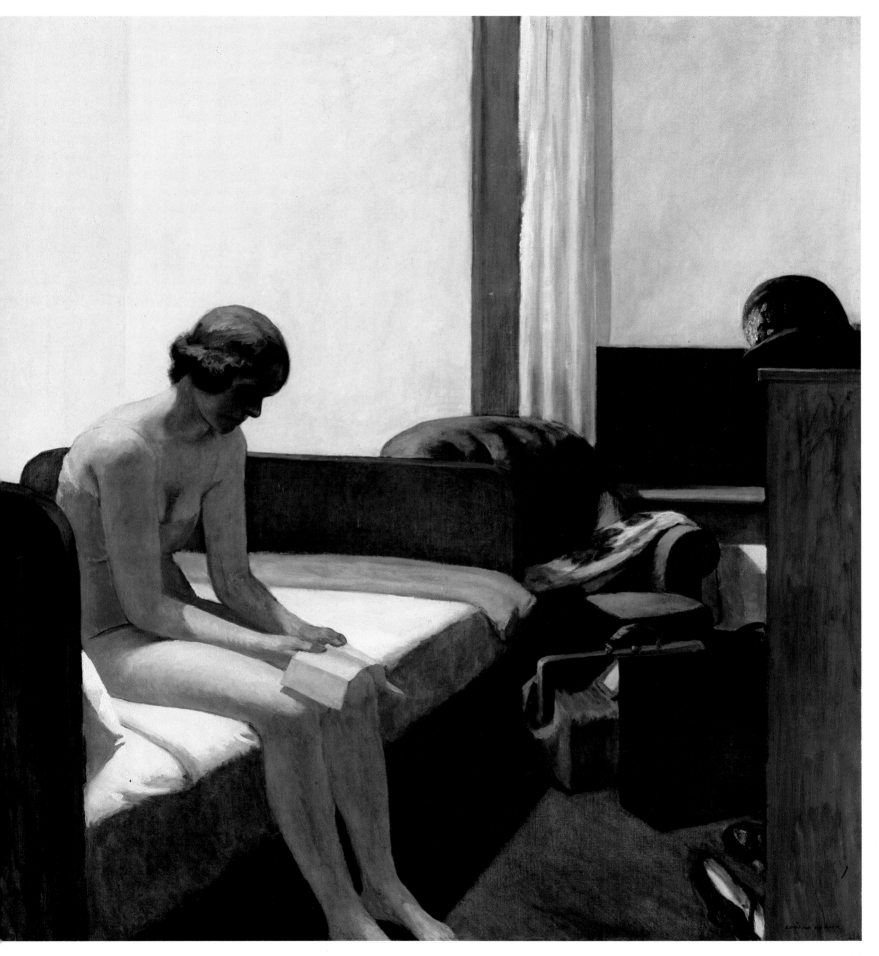

51
Stanley Spencer (1891–1959)
Love Letters 1950
Oil on canvas
34 × 46in. (86.5 × 117cm.)

The allegories of the British painter Stanley Spencer are usually contemporary in setting and religious in their message. *Love Letters*, however, is a personal confession.

In 1919 Spencer met Hilda Carline, a painter whose brother he already knew. In 1925, after several broken engagements, they were finally married. In 1933 they separated. Despite exacerbating differences, they remained attached. This mutual devotion lasted after their divorce and his remarriage. Spencer refused to accept the fact that they had parted, even after Hilda died in 1950. *Love Letters* celebrates their enduring, strange romance.

The same two figures, similarly juxtaposed, first appear in a pen and ink sketch contained in a letter written by Spencer to Hilda twenty years before. The swift outlines of the drawing detail the kneeling figures, their gestures, and the letters that each holds.

The painting, however, casts both adults as children, and this impression is strengthened by the giantesque scale of the chair. The girl looks down and draws an envelope from her bosom as she delivers another. The boy, smothered in ecstasy, kisses her written words. At the same time, he presses the opened envelope to his ear as if to listen to its address.

The two bodies, doll-like and curiously limp, do not actually touch. The immense chair, their love vessel, fills the composition and is cropped by the close-up view. Supported by a wooden frame, the chair's back, seat and flopping bolsters are upholstered in vinyl fur, a pressed and repellent surface. The textures of clothing — tweed, ruffles, satin, silk and embroidery — are as painstakingly detailed. The hideous pattern of the wall covering is no less tactile, and it shifts color as it passes behind the chair. At the extreme right is a curtained window.

Today, in England, the realist tradition of Spencer with its frequent psychological implications is eloquently followed by the self-taught painter Lucien Freud. His painting similarly, but more ambiguously, reduces an adult figure to the size of a child. And, his scene is also observed from above.

Naked to his undershirt, a disheveled dreamer rests awkwardly upon the floor. He seems vulnerable and, despite the intimacy of his pose, alien to his surroundings. The puffy face, thick shoulders, and small hands also appear inimical to each other. Is this intruder indeed a child? The large, tattered coat, hung from the knob of a folding screen, may indicate he is not.

The sun-struck window silhouettes the marvelously painted plant. Dominating the room, its tall thin trunks greet the light, and its unkempt withered branches reach toward the spectator. Freud's use of perspective is startling, and he changes his point of view. Nevertheless, with the single exception of the boy, the plant in its pot does not seem disproportionate in scale to the rest of the room. A few dead leaves have fallen. Like the prone figure, they rest upon the scuffed and dusty floor, a shallow river of neglect.

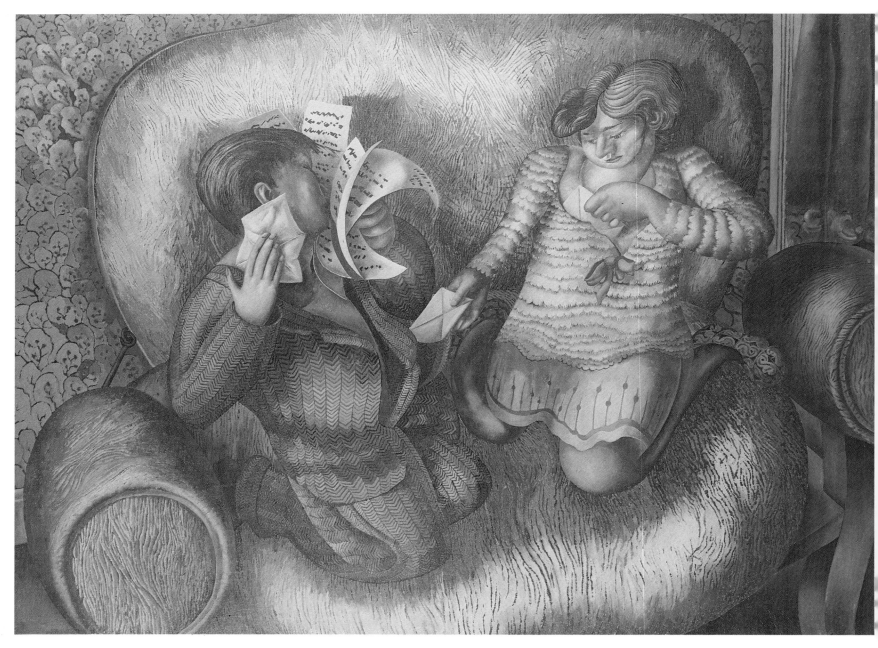

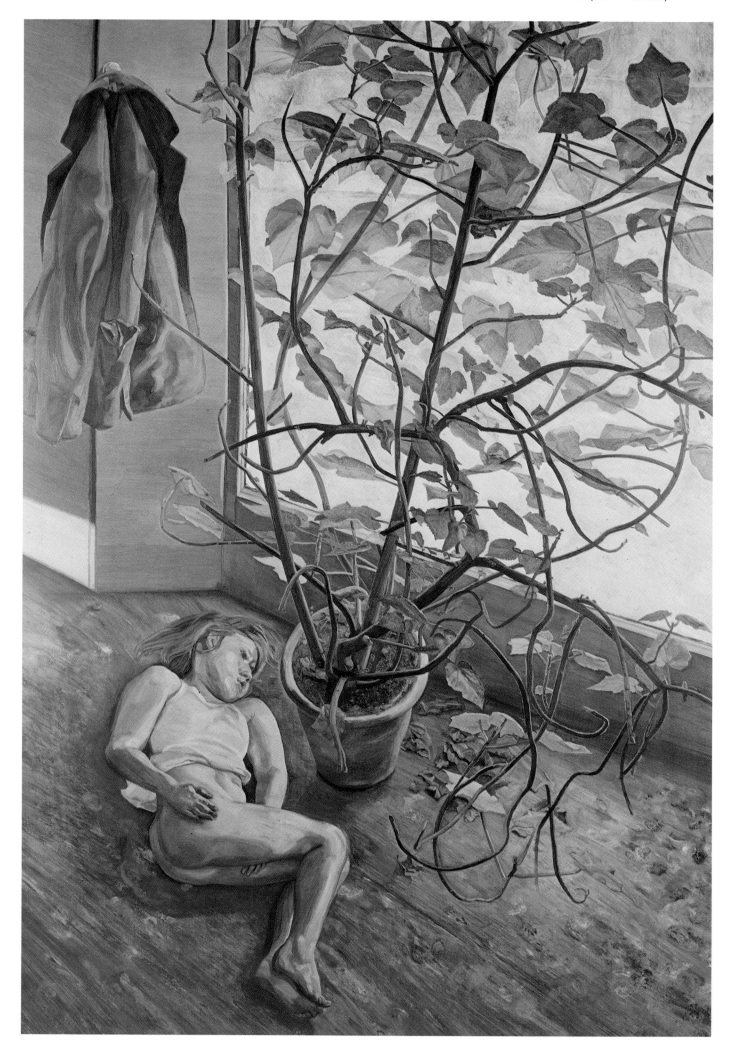

53
James Rosenquist (born 1933)
Smoked Glass 1962
Oil on canvas
24 × 32in. (61 × 81.5cm.)

After the Second World War, the American pin-up girl matured from Betty Grable to Marilyn Monroe, and during the 1960s her idealized image permeated Pop Art, particularly in the United States. In these two paintings, she appears in distress and in glory.

James Rosenquist's pictogram was painted in 1962, the year Marilyn Monroe died. His canvas, untypically small, serves as a screen on which he seemingly projects enlarged details of black and white photographs. What is seen is quite clear: a cigarette, a woman exhaling, and smoked glass of an automobile headlight. The images are fragments and they stand for the whole. Their complete shapes are familiar. Their juxtapositions, however, are completely unexpected, and their simultaneity and size upset reality.

In Rosenquist's painting, scale changes function, and the everyday identity of objects assumes additional meanings. Thus, the headlight becomes a menacing eye or a second orifice, ominous and mysteriously closed. The few images are blatant and disquieting, and they converge into sound. "I've been exhilarated," Rosenquist once said, "by a numbness I get when I'm forced to see something close that I don't want to see." Action is frozen, but something violent is about to happen.

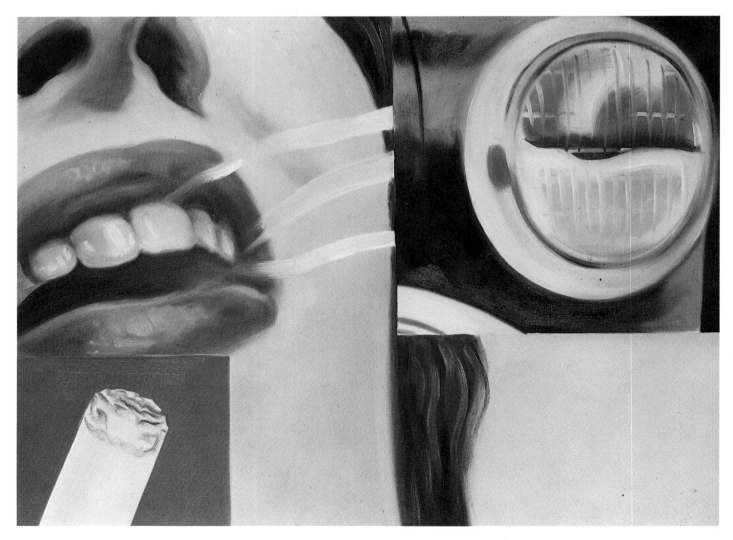

Like the dozen or so reclining nudes that Modigliani painted more than half a century before, Tom Wesselman's female figure stretches across the canvas. If they, or she, could rise and walk, how monstrous all would seem! In Wesselman's nude, however, no individual features particularize the model; indeed face and limbs are cropped.

Wesselman's poster-bright colors and abrupt juxtapositions, the latter not without humor, derive from his earlier use of collage elements clipped from advertisements printed in magazines. The flesh-tinted image lies flat, a cut-out decorated with three erogenous zones. The undulating contours of the incomplete body are silhouetted against similarly painted flat shapes. Curves and color create movements independent of the figure, and these are balanced at the left by the straight horizontal slats of the Venetian blind. Illusionary space is occasionally suggested, for instance the rounded orange (the navel of which seeks a female counterpart) and the cluster of opened roses. Both fruit and flowers provide explicit sexual metaphors.

A tilted frame, felicitously placed, contains the photograph of a man. A voyeur, his face sinks behind the recumbent billboard altar. This small macho icon, in black and white, is the artist's own self-portrait. His great American nude is also a great masturbatory dream.

54
Tom Wesselman (born 1931)
Nude, Number One 1970
Oil on canvas
25 × 45in. (63.5 × 114.5cm.)

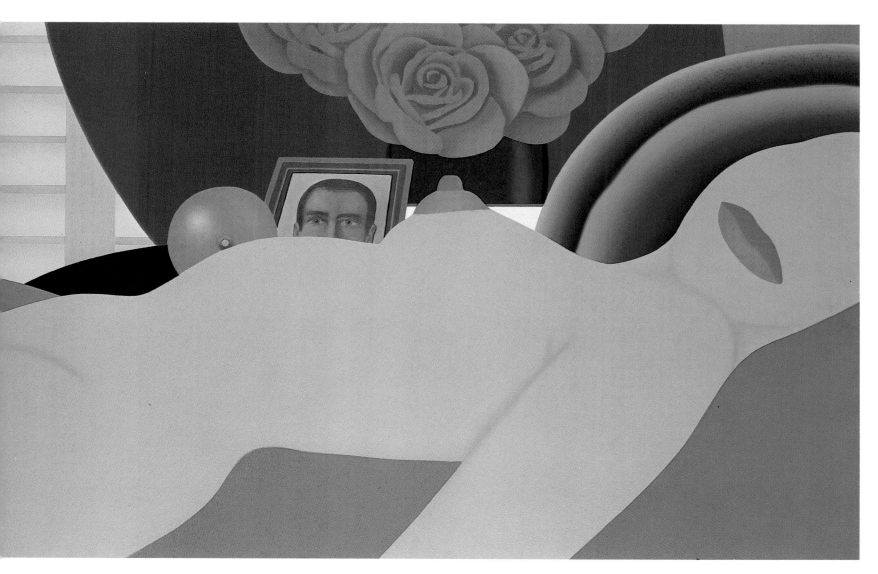

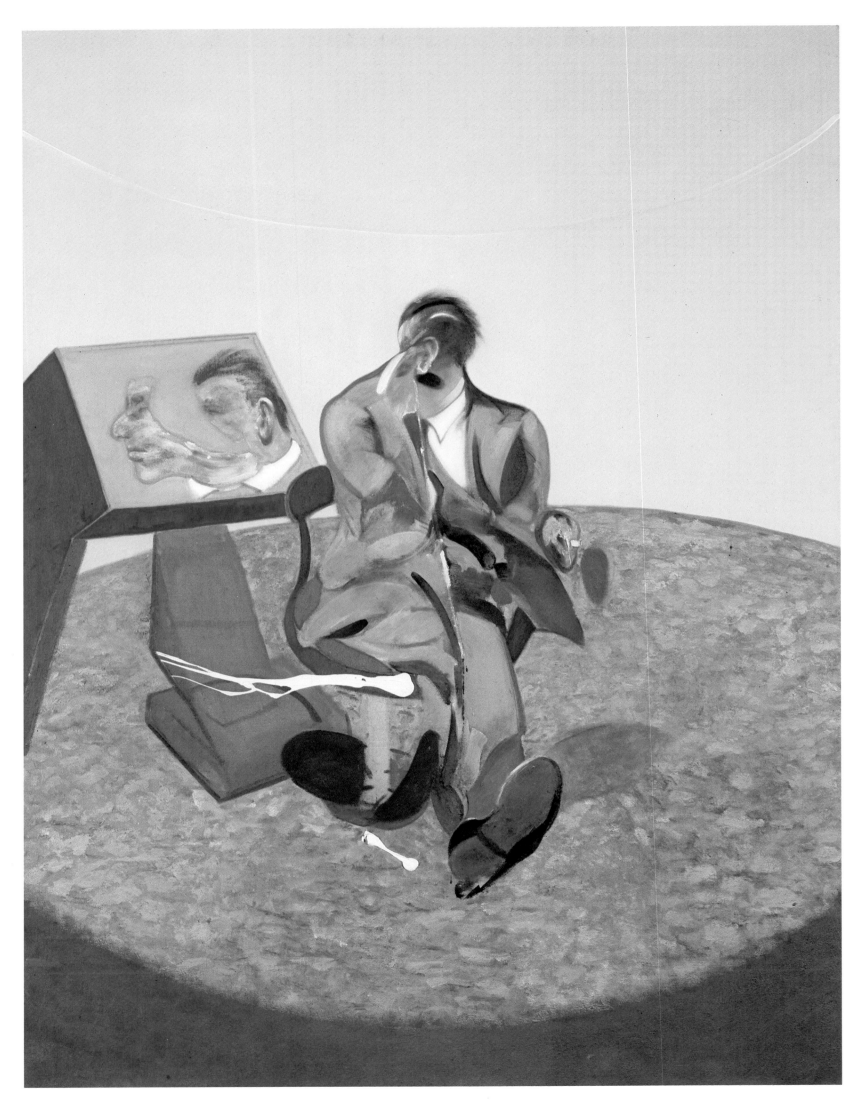

55
Francis Bacon (born 1909)
George Dyer before a Mirror 1968
Oil on canvas
77⅞ × 57⅞ in. (198 × 147cm.)

56
Ronald Kitaj (born 1932)
Smyrna Greek, Nikos 1976—7
Oil on canvas
96 × 30in. (244 × 76.2cm.)

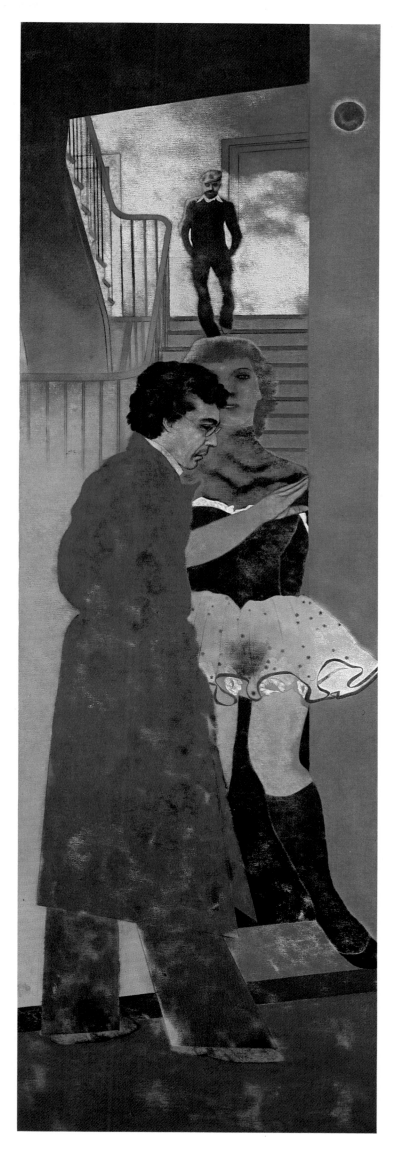

A strong tradition of figure painting is a continuing characteristic of British art, and since his first one-man exhibition in 1949, Francis Bacon has been a master of that tradition. As a painter, he was self-taught. The authority of his style, however, transcended whatever influences may have contributed to its development. Bacon's perception is intuitive and unerring, and he finds the marvelous in the frightening and even sordid aspects of human experience. With a poet's eloquence, he underscores the isolation of the individual within the deep despair of our time.

During the 20th century, many artists have assaulted the image of man, but none with more ferocity. Every physical feature of George Dyer, the subject of this double portrait, was intimately known to the artist. In a dozen other compositions of the same size, Bacon presented him full-figure and usually similarly seated. Indeed, Bacon knew and understood his subject so well that he had no need to paint directly from the model.

In the Thyssen-Bornemisza portrait, a circle of harsh light captures the seated figure whose likeness is brutish and violent. Confined to a chair, the man swivels toward and away from his own reflection in a mirror, an awkward piece of furniture resembling an X-ray machine or a television set. The human hulk, twisted and stripped of dignity, seems grotesque and vulnerable. The savaged face is presented twice: the concealed profile of the seated figure, and the cleft reflection that coalesces into one extraordinary image. The mood is tense and pitched to terror.

The camera has always played an important role in Bacon's pictorial intelligence, and the dazed figure recalls blurred movements ineptly captured by ''vintage'' pornographic photographs. Two white splashes lie flat on the surface of the canvas. These unexplained drippings are agitated, and they are compositionally more relevant than recognizable details such as the cigarette held in Dyer's left hand. Bacon's allegory is ambiguous and it remains private. The seated figure is the protagonist; the fractured image is the victim. Only the artist knew both. George Dyer committed suicide in October 1971, a few hours before the gala opening of Bacon's large retrospective exhibition at the Grand Palais in Paris.

R. B. Kitaj is also primarily a painter of the human image, but there is nothing impetuous about his style, and every inch of his canvas is controlled. The tall and narrow format seems unusual, but it conforms to that of several imaginary portraits that Kitaj painted during the late 1970s. At the top, and in the exaggerated distance of what should be shallow space, a bearded man with a cap jauntily descends a staircase. Below, and presumably at street level, stands a woman. Her features are blurred, and despite her deliberately provocative appearance, she folds one arm in a protective gesture. In the street, and in profile, a man pauses. He can hardly be oblivious to the woman's proximity, but will he stop? A red light at the upper right identifies the scene. The spectator, however, must supply his own scenario. This is exactly what Kitaj wants. In his mind, he had established individual case histories for each of these three characters before he painted them. Kitaj knew who they were and what they did. As he has said, ''I like the idea that it might be possible to invent a figure, a character, in a picture the way novelists have been able to do — a memorable character, like the people you remember out of Dickens, Dostoyevsky, Tolstoy.''

The composition is taut. Its setting, its architecture and spatial adjustments are carefully considered almost as an intellectual exercise. In addition, Kitaj allows clouds to drift on the landing, and he flatly geometrizes certain forms, for instance the hem of the man's long coat, his trousers and his feet.

Kitaj, an American, lives in London where he has been a mentor to several younger British artists. His drawings, particularly his pastels, influence his technique of painting; and, in completely different styles, he has been an innovative and prolific printmaker. Several years ago, before he briefly returned to the United States as an artist-in-residence at an American college, he paid an informal farewell to Bacon. The elder artist asked ''What is there left to teach?''

Arthur Dove (1880–1946)
Blackbird 1942
Oil on canvas
17 × 24in. (43.2 × 61cm.)

Arthur Dove's faith in his direct relationship to nature was an essential nutrient to his art. He believed in a life force, and he sought to translate its rhythms into pictorial equivalents. In his paintings, its pulse is often symbolized by dark forms, from which emanate dynamic vibrations of life itself.

Thirty years before he painted *Blackbird*, Dove probably created the earliest abstract images produced in the United States, which were shown by Alfred Stieglitz at his gallery "291." At that time, Dove wrote to a friend, who was also the first American collector of Kandinsky paintings: "I gave up trying to express an idea by stating innumerable little facts The first step was to choose from nature a motif in color and with that motif to paint from nature The second step was to apply this same principle to form, the actual dependence upon the object disappearing, and the means of expression becoming purely subjective."

Another artist, even more intimately associated with Alfred Stieglitz, is Georgia O'Keeffe. Wondering why an exhibition devoted to her achievement has never been presented abroad, the Baron Thyssen-Bornemisza became her chief European collector, and he recognizes her as America's foremost living painter. He has not chosen examples of her popular subjects, bones, the cross, and horticultural specimens. Rather, he prefers her paintings of landscapes and city architecture, and, less familiar, those few that visualize sound and its vibrations.

Severe beauty, sharp focus, and meticulous craftsmanship are characteristic of O'Keeffe's style. A characteristic of her art is her reworking of the same image, each time in a decisive and different interpretation. *From the Plains* has two companion pieces, one painted a year before, and an earlier canvas of 1919 which first presents the theme. As Lisa M. Messinger has written: "A jagged arc flashing across the sky dominates all three paintings. Of the first and the smallest, O'Keeffe wrote that her inspiration had been her memory of cattle driven across the dusty plains of Texas, and at night and penned in corrals, the 'rhythmic beat' of their sad utterances.

"In the two later paintings, scale and sense of space are changed. The size of both canvases is greatly increased and their horizontal format is exaggerated. Thirty-five years later O'Keeffe was no longer witness to the seminal incident. She generalizes to reveal the openness of the plains, a dramatic sense of light, and perhaps, through vibrant color, the intensity of noise that she earlier remembered as 'loud and raw under the stars in that wide empty country.'"

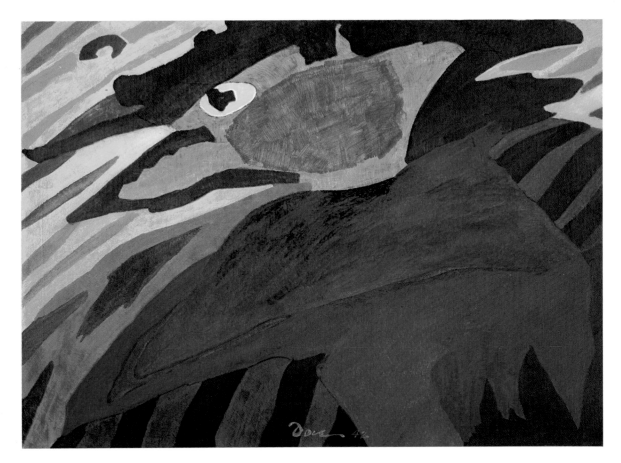

Arshile Gorky (1904–1948)
Hugging 1945
Oil on canvas
25½ × 32½ in. (64.7 × 82.7cm.)

Hugging, formerly owned by the Museum of Modern Art in New York, and its subsequent and slightly smaller companion *Impatience*, now owned by Mr. and Mrs. Sidney Kohl in Milwaukee, were painted in the year of Gorky's first one-man show at Julien Levy's gallery on East 57th Street in New York. To the exhibition's catalogue, André Breton, the instigator of Surrealism if not the inventor of its name, contributed a short essay that admitted the young painter, an earlier immigrant, to the Surrealist coterie then exiled from Paris. In New York, the Surrealist group featured Breton as pope in Babylonian captivity, and it included not Dali, who also exhibited with Levy, but the painters Max Ernst, André Masson, and Yves Tanguy, and, Dada of them all, Marcel Duchamp. Most important for Gorky, however, was Matta, a young and relatively unknown Chilean painter, who was also a protégé of Breton and who had first shown with Julien Levy in 1940.

By 1940 Gorky had already studied Ingres, Cézanne and Picasso, and he also admired the lyric abstractions of Kandinsky such as *Painting with Three Spots* (no. 14), then owned by The Museum of Non-Objective Painting (The Solomon R. Guggenheim Foundation). It was the liberated style and diaphanous color of Matta's abstract landscapes, however, that served as the catalyst that released Gorky's personal vision. Matta's own painting, fluid in composition and dramatic in expression, described cataclysmic encounters in a mysterious cosmos that evoked the future or the primordial past.

During the winter of 1941–42, Gorky was able to review the two divergent paths of pictorial Surrealism in concurrent retrospectives of Dali and Miró at the Museum of Modern Art. Gorky himself had assumed the path alternate to the frozen painted dreams of Dali (no. 41). As a draftsman, Gorky could be similarly precise and equally exact. But in the early 1940s, his art assumed a freer direction relying upon observation as well as upon automatism and accident, the second and less realistic path of Surrealism followed by Miró. Gorky was particularly impressed by two periods in Miró's development as a painter: his graphic synthesis of single themes in the 1920s (no. 39), and his abstract compositions of the 1930s where seemingly biomorphic forms float flatly on the surface of the canvas.

Gorky, today, is conveniently categorized as the last Surrealist and the first Abstract Expressionist. This is true. However, Gorky considered his art to be in the tradition of Western painting beginning with Giotto and Uccello and reaching to his own time with Ingres, Cézanne, and Picasso. In addition, Gorky remained an easel painter, and although his paintings may seem gestural and spontaneous, preliminary drawings on paper were essential to their creation. His last painting, *The Black Monk* in the Thyssen-Bornemisza Collection, is perhaps a single exception.

On canvas Jackson Pollock coalesced drawing into painting in the free choreography that so personalizes his style. This, however, was not Gorky's method. He evolved his painted images from penciled sketches, and usually he squared a final study on paper for enlargement onto canvas. A comparison of Gorky's drawings to his paintings shows the direct translation of

pencil to the painted line. In *Hugging*, for instance, Gorky used a long thin brush to repeat in oil on canvas configurations that he had already conceived on paper. Color was applied with a broader brush and then wiped and sponged to transparent washes that resemble watercolor. Last, with pigments of black, green and red, Gorky reinforced or filled the linear structure that he had already established.

Harry Rand's recent study, *Arshile Gorky: The Implications of Symbols,* is the essential key to Gorky's iconography, and it explains the painter's metamorphic balance between depiction and autobiography. Rand demonstrates that every painting by Gorky can be unskeined to reveal actual forms that he had studied in nature or indoors. *Hugging,* thus, appears to be an interior where at the left, and seated on a couch, a couple embrace. *Hugging* anticipated *The Calenders,* a larger and more opaquely painted interior collected by Nelson A. Rockefeller but destroyed by fire in 1961, a tragedy subsequent to Gorky's own desperate loss by fire of twenty-seven paintings in 1946.

Untypically, Gorky's last painting was conceived directly and quickly on the canvas, which accounts for its gestural boldness, a characteristic of Abstract Expressionism. Configurations are no longer thinly outlined. They are aggressive, and with slight exceptions, they are broadly brushed. Harry Rand, again, illuminates the painter's iconography. Shortly before his death, Gorky had admired Anton Chekhov's short story *The Black Monk* which recounts the degeneration of man whose final deliria are accompanied by an extraordinary apparition of a black monk. Rand sees this hallucination as the large advancing image that fills the canvas, its head painted black, its body white, and its arms outstretched. In Chekhov's story, the hero suffers a hemorrhage and collapses to die in a pool of his own blood, an incident reduced and synoptically recorded in Gorky's painting on the white vestments of the black monk. Rand's detailed interpretation is thoroughly convincing, and he concludes: "To paint this story was to paint a suicide note."
In June 1948, Gorky's neck was broken and his right arm immobilized by an accident in an automobile driven by Julien Levy. Gorky had

60
Arshile Gorky
The Black Monk 1948
Oil on canvas
30¾ × 39¾ in. (78.1 × 101 cm.)

only recently discovered that he was a victim of cancer, and he was also beset by marital misfortune. He felt himself alone as a man and unrecognized as an artist. In his studio a month later he committed suicide by hanging. He was forty-four years old.

61
Stuart Davis (1894–1964)
Pochade 1958
Oil on canvas
51 1/8 × 59 3/4 in. (130 × 152cm.)

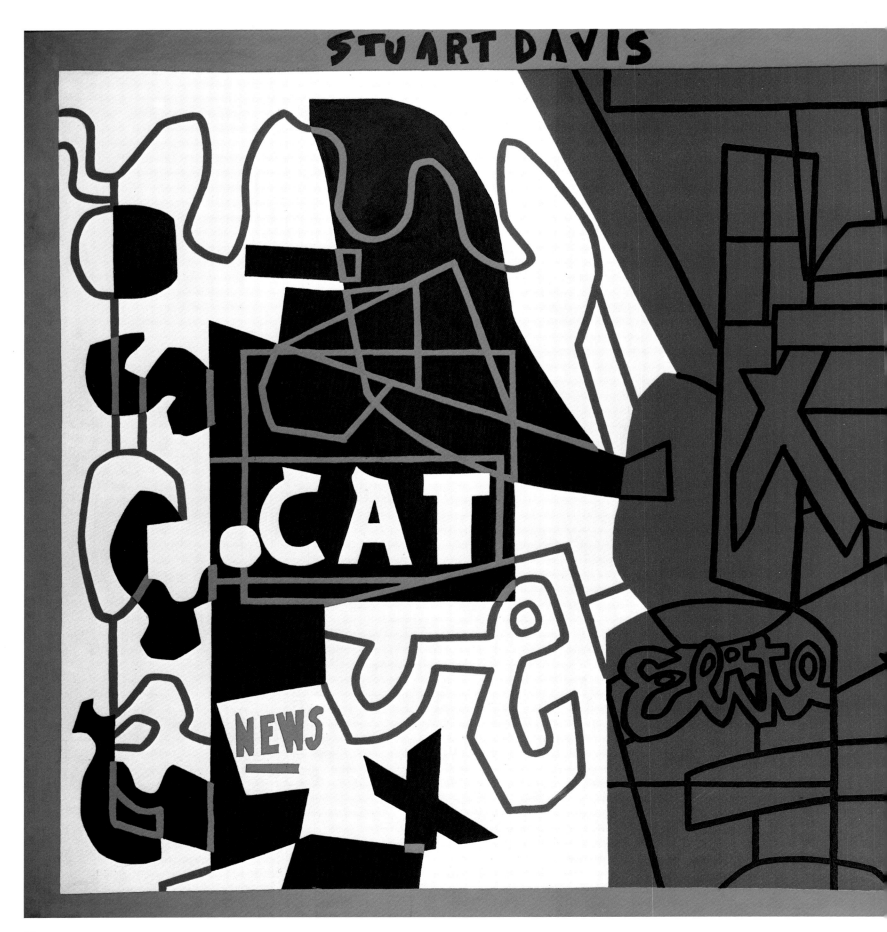

In 1928, the American painter Stuart Davis made his only visit to Paris. He worked and he walked and he looked. In dealers' galleries he may have seen paintings by Léger and Mondrian, but his sojourn and his distance from New York consolidated and confirmed his own theories in an ambiance that was stimulating, as well as conducive to their maturation. Before Davis left for Paris, he knew what path he would follow. When he returned to New York, he never wandered from it. Davis never forgot his fifteen months in France.

During the 1930s, in New York and in need of money, Davis executed several mural commissions. When he resumed easel painting his compositions clearly reflected the expansion of scale of that experience. *Pochade*, painted in 1958, late in his career, is perhaps his most complex image. Unlike the subsequent *The Paris Bit*, in the collection of the Whitney Museum of American Art, *Pochade* is difficult to read. The dictionary identifies "pochade" as a French word, and defines its meaning as "a rough or quickly executed sketch or study." That is exactly what this *Pochade* is not. In choosing a name for his painting, however, he may have remembered the many, much smaller sheets of paper on which he had so tightly outlined its composition.

The structure of *Pochade* is linear, and in 1960 Davis explained why: "It is traditional to think of drawing and painting as two different things, a concept which has its own logic. However, my temperament has led me . . . to regard them as an inseparable unit I gradually learned that it is impossible to make any mark on a surface without setting up a positional color relationship. I compose and develop my picture as a line drawing because it is a method most amenable to inspiration and change, in addition to its demand for positive decisions."

"Positional color" supplies pictorial emphasis to *Pochade*. Black at the left is form, red at the right indicates a specific, interior space. What is seen in *Pochade*, it has been suggested, are dual aspects of Davis himself. Silhouetted in profile facing left, the "cat" is Davis the jazz enthusiast, seated and smoking a cigar; and, at the right, the "elite," an interior of the artist's studio, replete with a television set.

The single thick band that emphasizes the rectangle of the composition creates a border. This frame contains a running and syncopated calligraphy of cursive and straight lines, each of which measures the same width. The painted letters, of course, form words; and, for Davis, words were part of urban life and therefore subject matter. Juxtaposed with visual symbols, for instance the round white spot and the black "x," these letters have an iconographic relationship that here remains private to the painter. However, "any" and "news" are other discernible words, and together they pose a frequent question. Additional groups of letters may exist, but in the painting their ligature is so syncopated that it is illegible.

With typographical emphasis Davis wrote in 1957: "I see the Artist as a Cool Spectator-Reporter at an Arena of Hot Events." In *Pochade* his own name is featured at the top. He frequently incorporated his signature into the compositions of paintings, but never before, nor after, did he so prominently letter it out.

More than a generation separates Stuart Davis from Robert Rauschenberg. Yet only five years stand between *Pochade* and the mural size painting reproduced across the following spread. In the development of both artists, collage was an important factor. In *Express*, however, Rauschenberg capitalizes on technological advances in printing, specifically silkscreen, that Davis only once attempted. Unlike Davis, he multiplies rather than distills his impressions. A photographer himself, Rauschenberg treats photographic images like words and quotations. He constructs syntax, and he accents inflections. In *Express* he projects narrative paragraphs on so broad a scale that their lateral sequence encompasses the spectator.

The photo-images that Rauschenberg selected for *Express* were in turn photographically enlarged on sensitized silk-screens. These were then prepared for printing onto the large canvas. Rauschenberg uses the individual pictures as collage elements, and inherent in the silk-screen process is its ability to repeat, for instance the horse jumping the hurdle. Rauschenberg unites the images by juxtaposition and with broadly painted brushstrokes. The resulting panorama is confined to tonalities at that time usually associated with photography. A single exception is the red rectangle that recalls a similar element in Rosenquist's *Smoked Glass*, a painting also based on photo-images (No. 53).

"Express," as a word, implies rapid movement, and Rauschenberg serves up a battery of appropriate illustrations: jockeys on horseback, dancers, mountain climbers, and, in multiple exposures, a nude walking. Anchored at the lower corners of the mural are a Chicago bridge and under it a boat, and at the right and "expressing" themselves, the two most distinguished generals of the Civil War. In other paintings, done before and after, Rauschenberg repeated several of these pictorial paragraphs.

Express obviously owes much to the camera, moving and still. It is also witness that for almost a decade Rauschenberg was closely associated with Merce Cunningham, the choreographer and dancer who continues to influence the pictorial perceptions of the American avant-garde.

73

63
Mark Tobey (1890–1976)
Earth Rhythm 1961
Oil on canvas
26¾ × 20in. (68 × 51cm.)

In mid-career, both Mark Tobey and Mark Rothko changed the direction of their art. Tobey renounced a conventionally realistic style admired by the world of fashion. Rothko's first works, expressionist in style, had been addressed to the proletariat. Tobey's transition towards abstraction lasted longer, Rothko's career was cut short by suicide. Both are among those rare artists who through their painting express spirituality.

Tobey sought to "make the intangible tangible," and he believed that "multiple space bounded by involved white lines symbolizes high states of consciousness." His best paintings are small, and each condenses into a precious microcosm, energy and light, captured in the magic web of his calligraphy.

Rothko worked on a much larger format, and in 1951 he explained why. "I paint very large pictures The reason I paint them . . . is precisely because I want to be very intimate and human. To paint a small picture is to place yourself outside your experience However, you paint the larger picture, you are in it. It isn't something you command."

Rothko thought of his pictures as dramas, and this conception, as well as his emphasis on scale, perhaps explain why he is so consistently identified with the Abstract Expressionists, his contemporaries in New York. Actually, Rothko shared neither his friends' commitment to gesture nor their sensual manipulation of paint. His colors are never revealed in strokes, and he took great effort to minimize their texture. During the last two years of his life he painted in acrylic. He found its opacity and quick drying properties particularly suited to his method, and paper became the primary support of his paintings.

By 1951 Rothko had evolved the personal imagery that he refined and simplified during the next two decades. His compositions conform to a consistent structure: two or three wide horizontal bands of unedged color float weightlessly against an equally flat background that they almost fill. These compositions, always frontal, are completely flat. The only suggested inter-relationship of their sparse elements to illusionary space is the placement of the varying widths and their differences in color. Like most of Rothko's last works, his painting in the Thyssen-Bornemisza Collection reveals a somber mood. Rothko, almost to the end of his life, believed that painting was a miracle, a revelation. When he doubted this mystical process, he died.

Tobey, a less driven artist, was personally graced by humor. He was fond of repeating a story that is as pertinent to the art of Rothko as it is to his own. "The old Chinese used to say: it is better to feel a painting than to look at it. So much today is only to look at. It is one thing to paint a picture and another to experience it; in attempting to find on what level one accepts this experience, one discovers what one sees and on what level the discovery takes place. Christopher Columbus left in search of one world and discovered another."

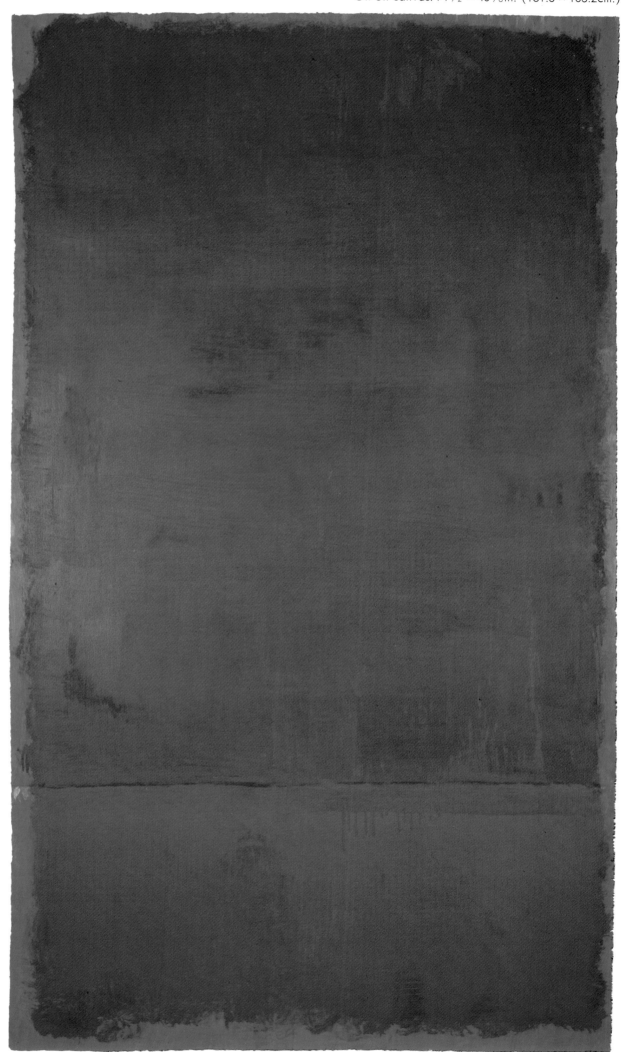

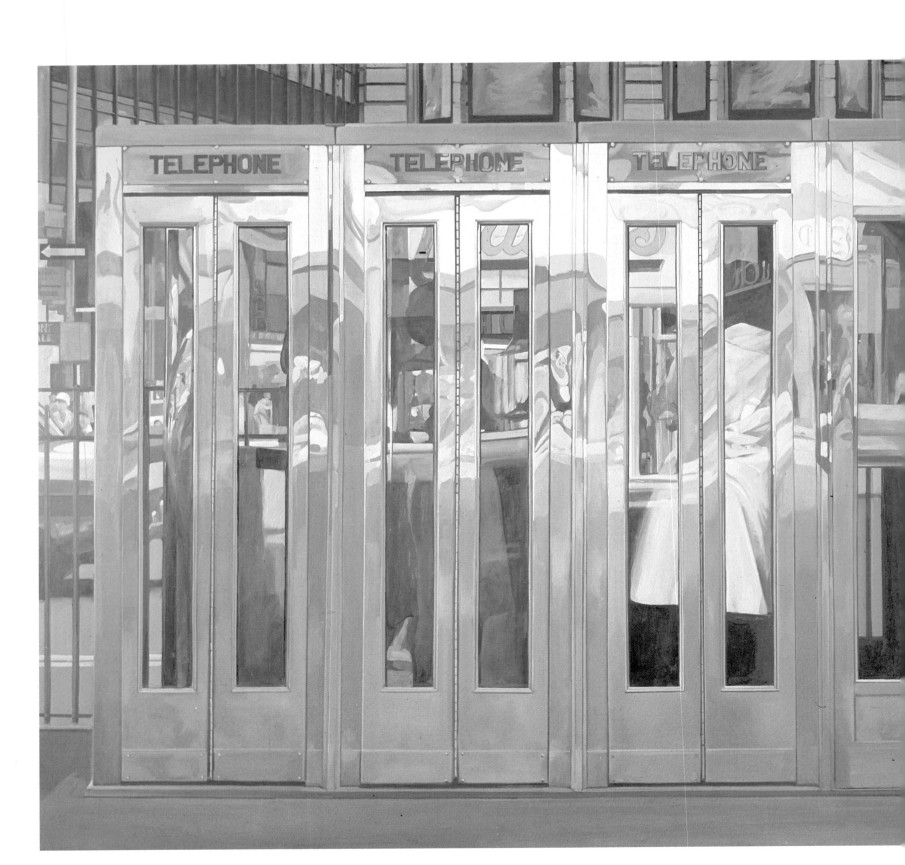

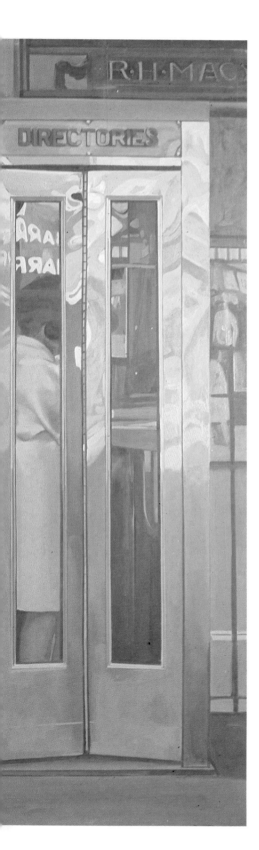

At the convergence of Broadway and Sixth Avenue at 34th Street, one of the busiest crossings of vehicular and pedestrian traffic in New York, only the most intrepid of artists would set up an easel to paint four telephone booths. And, this is exactly what Richard Estes did not do.

From different viewpoints and at different times of day, Estes used a thirty-five millimeter camera to photograph an incident or urban landscape that is so familiar it is banal. Once his exposures were developed, he carefully edited the photographs to select those few that he would combine into a composite scene. Certain facts became irrelevant and they were discarded, for instance paper jetsam floating on the city's streets. Last, with adjustments in scale and relationship, he outlined the composition on his canvas.

For Estes, the explicit articulation of pictorial synthesis is more important than narrative or exact truth. Light and color may not be faithful to the original scene. Their rendition, however, is completely convincing. Regardless of spatial distance, even the slightest architectural detail assumes importance, and each is essential to the rigid balance of the picture's pattern. As did Charles Sheeler, he exploits the geometry inherent in any element that he paints. People, in Estes's painting, are unimportant, completely incidental to the man-made environments to which they themselves did not contribute.

Estes's gridded view offers a virtuosic interplay between reflection and reality, and at first their conjunction is ambiguous. In the mid-1920s Atget had manipulated similar effects in his photographs of Parisian storefronts. What is seen through the long glass windows and what is reflected are both painted with equal emphasis. The moiré of mirrored images suggests movement, and there is also real traffic in the streets. The color of parked "Yellow" taxis is reflected on glass and metal, and just beyond actual taxis cruise Broadway.

These four telephone booths stood on the southern tip of the thin triangle of cement that forms Herald Square. The rectangular motif of doors is lateral, formal and severe, and Estes has adjusted the diagonal facade of the building across the street to match its frontal alignment. The view is from 1316 Broadway, and the building opposite is Macy's department store. At the left appears the sheath of 112 West 34th Street with its F. Woolworth's at ground level. Today a quartet of different pay phones has replaced Estes's gleaming closets of glass and unnaturally polished steel. The open iron grille running parallel behind the booths remains.

During the twentieth century each generation has triumphantly revived realism, and only yesterday fanfare sounded to "Super Realism" and "Photo Realism." Estes's *Booths* was painted shortly before his first one-man show in New York. Since then, and for more than a dozen years, he has been the young old master of American realism's most recent "revival." Estes never projects directly from the photograph, nor does he grid photographs for transfer onto canvas. Only his selective eye could find extraordinary harmony in such an ordinary scene.

Would Mondrian have admired this painting?

66
Domenico Gnoli (1933–70)
Armchair 1967
Oil and sand on canvas
79 7/8 × 56 1/4 in. (203 × 143cm.)

Suddenly, the spectator is surprised by one dominant image that hugely
fills the canvas. Such a confrontation is unexpected, and if all four sides
of the painting were trimmed, the composition would offer only a pretty
pattern in two shades of the same color.

With insouciance, the inanimate ordinary chair assumes a living identity.
One asks if its skirt is flirtatious or discreet. The chair's symmetrical
placement is emphasized by the floorboards that abruptly tilt to the
wall. This balance is manipulated but not disturbed by a deep shadow
in the lower right, and by the two halved images, a socket and the back
of a head, on top. Wit is not easily translated into paint.
Here, however, one is astonished as well as delighted, and the
chair is certainly more significant than its unseen occupant.

Domenico Gnoli, born in Rome, died in New York at the age of thirty-
seven. In an interview less than two years before his death he said:
"I left for America, where I stayed until 1963; I lived for a long time
on journalistic illustration which I did for the big magazines like *Fortune*.
I have always worked as I do now, but nobody noticed it at the time,
as the fashion was for abstraction. Now my painting has finally become
understandable, thanks to Pop Art.

"I like America, but my attachments are exclusively Italian. I am
metaphysical in the sense that I work towards a style of painting which
is not eloquent, which is immobile and atmospheric, which is fed on
static situations. I am not metaphysical in that I have never tried to
create a scene, to fabricate an image.

"I always use elements which are given and simple; I never want to
add anything or to eliminate. I have never had any desire to deform;
I isolate and I represent. My themes come from the present, from
familiar situations, from daily life; because I never intervene actively
against the object, I feel the magic of its presence."